# SECRET BEDFORD

## Paul Adams

AMBERLEY

*For Jeni Melia*

First published 2018

Amberley Publishing
The Hill, Stroud
Gloucestershire, GL5 4EP

www.amberley-books.com

Copyright © Paul Adams, 2018

The right of Paul Adams to be identified as the
Author of this work has been asserted in accordance
with the Copyrights, Designs and Patents Act 1988.

ISBN  978 1 4456 7696 8 (print)
ISBN  978 1 4456 7697 5 (ebook)

British Library Cataloguing in Publication Data.
A catalogue record for this book is available from the
British Library.

Origination by Amberley Publishing.
Printed in Great Britain.

# Contents

# Introduction

As an important county town, Bedford has enjoyed a rich and varied history. It is also a town that has, to its great advantage, had this history set down and examined in considerable detail over the course of many years. In recent times the diverse source of local knowledge known to many Bedfordians who have grown up and lived here has, thankfully, been preserved for posterity in several specialist books that have covered a wealth of home-grown subjects, from choral singing to estate agents.

The question should then be asked, why does Bedford need another history book? In *Secret Bedford*, as with another book in this Amberley series on Luton, I have attempted to answer this question by setting down what is hopefully an interesting mixture of facts and accounts which are decidedly off the beaten track where previous collections are concerned. Although some general history is included to set the scene, I have tried, where possible, not to revisit the work of previous writers and historians. This is why, for instance, instead of brick and lace making you will find connections to a famous English ghost hunter and the first British performance of a well-known Russian symphony, and notable figures such as John Bunyan and John Howard could be considered as conspicuous by their relative absence and are only mentioned briefly in passing.

It goes without saying that if I have been able to investigate, discover and set down all of the various stories, histories and details that you are about to encounter, then undoubtedly other people will know about them as well. However, not everyone knows everything. I hope that by bringing *Secret Bedford* together it will introduce an eclectic undercurrent of local history that will be of interest to Bedfordians both young and old, and if every reader of this book says at some point, 'Well, I never knew that,' then it will have served its purpose.

I hope you enjoy this book as much as I have done researching and writing it.

Paul Adams
Bedfordshire, 2018

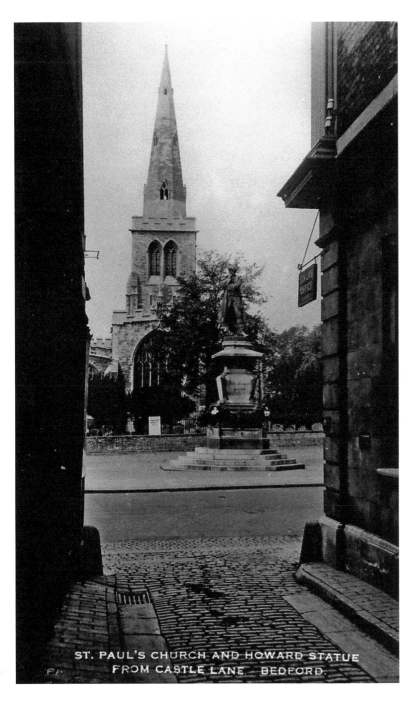

ST. PAUL'S CHURCH AND HOWARD STATUE
FROM CASTLE LANE BEDFORD.

A historic view of the Howard statue and St Paul's Church from an early twentieth-century postcard. (Author's collection)

# 1. Ancient and Historical Bedford

Much has been written about the history of Bedford and this opening chapter is really a brief account of certain periods to set the scene. Like any town, Bedford's history is a product of its people, both indigenous and visiting. Several of these native and temporary Bedfordians will be encountered in the pages that follow, mostly in times that are near to us and can still be recalled by many townspeople today. We start, however, by journeying far back into the past.

The first Bedfordians, as it were, lived in a world that we can only imagine: the Palaeolithic or Old Stone Age, which started from around 2.5 million years ago up until around 8000 BC. Relics from this distant time in the form of hand-axes have been unearthed in several locations across the present-day town and surrounding area, including de Parys Avenue, south of the River Great Ouse at Cauldwell Street and in Fenlake, and at Summerhouse Hill, near Cardington. Similar items also represent the Middle or Mesolithic Age (8000–3500 BC) and Neolithic or New Stone Age period, the latter ending around 1600 BC. A Mesolithic antler handle for a flint blade was recovered from the Great Ouse at Goldington, while Neolithic axes have been found in Furzefield and Kimbolton Road, and at Bury Farm also in Goldington, a henge complete with skeletons together with evidence of later Bronze Age activity. This period saw the gradual change from the use of flint tools during a time when the establishment of agriculture also brought to an end the nomadic hunter-gathering lifestyle of the Stone Age people.

By around 1000 BC, Britain was to see a gradual influx of peoples. These newcomers would bring with them a common tongue, a shared Celtic heritage and introduce further advances in metalworking technology which would give the epoch a new name. Iron Age Britain is thought to have lasted from around 800 BC to the arrival of the Romans in 55 BC. Iron Age relics have been recovered in Bedford, including pottery and human remains, while in 2001, two roundhouses used by Iron Age farmers were found in the riverside fields south of Oakley Road during construction of the A6 Clapham bypass. In that time the country had become settled by a patchwork of neighbouring Celtic tribes who continuously competed with each other for dominance and supremacy. Included among them were the Iceni, who controlled what is now modern-day Norfolk and Suffolk. On the south-east coast the Canti held sway. From them the county of Kent takes its name. Up on the north-east coast, near modern-day Lincolnshire, was the territory of the Parisi.

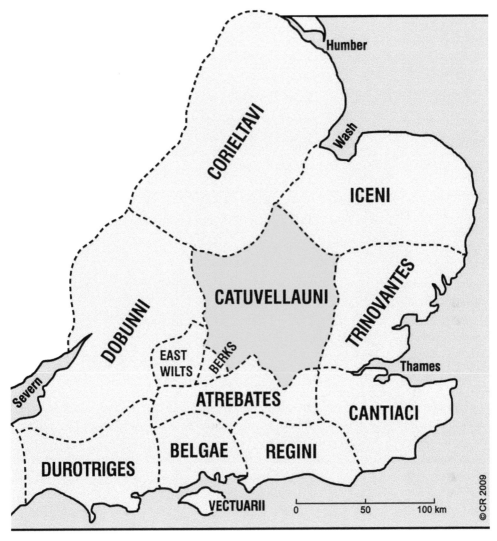

Pre-Roman Britain, showing Bedford's location within the territory of the Catuvellauni tribe. (Eddie Brazil)

DID YOU KNOW... ?

If you had been resident in what is present-day Bedford 2,000 years ago you would have been one of the Catuvellauni tribe. The Catuvellauni were a fierce, Celtic-speaking, spiked or long-haired warrior race who painted their bodies in blue woad and charged into battle, either on foot or mounted on armoured scythe-wheeled war chariots. Their original capital was based at Wheathampstead, just over 6 miles south-east of Luton, while their territory extended over what are now the English counties of Bedfordshire, Hertfordshire and Buckinghamshire, and north into Cambridgeshire.

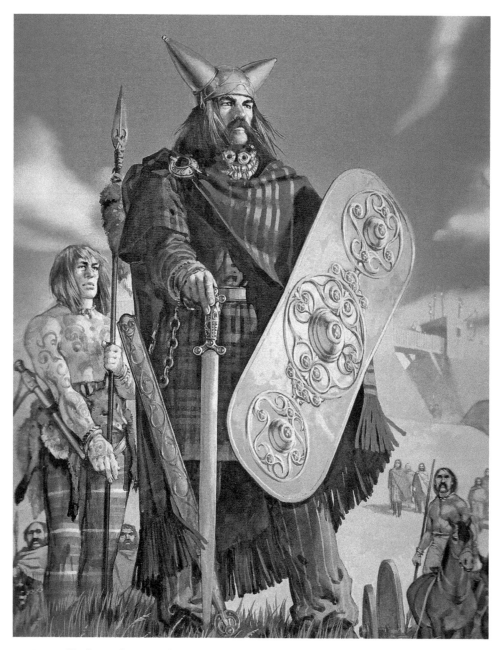

Ancient Bedfordians: the Catuvellauni warriors. (Eddie Brazil)

The Roman occupation of Britain lasted over 400 years. Those Celtic tribes who had refused to submit to the rule of Rome fled west to Cornwall and Wales, or across the sea to Brittany. For the ancient Bedfordians, life must have continued much as it had done for

centuries, as during the Roman period it remained a series of scattered farmsteads. The first urban settlement nearby was the small Roman town of Durocobrivis – modern-day Dunstable – where the legions created the road, possibly as a strategic measure, now known as Watling Street at its junction with the Icknield Way. This is considered to be one of the oldest continuous trackways in the country, running from Norfolk to Wiltshire.

The signs of the Roman occupation of what would eventually become Bedford are somewhat sparse, although only relatively recently, in 2011, a major find took place on land off Manton Lane in the northern outskirts of the town when the painted walls, glazed windows and the under-floor heating system (or hypocaust) of a large Roman villa were discovered. The Romans, however, would come to leave their most substantial footprint in the area closest to Bedford at St Albans. Here one can still see the remains of the amphitheatre and the former city walls, but in reality the clock was ticking for the victorious armies of Rome. Four centuries after their triumphant arrival, barbarian raids on the eternal city had forced the legions to return home. Britain was left to defend itself from invaders from Scandinavia and Germany. The English were coming.

DID YOU KNOW... ?
Although it is generally agreed that the name Bedford comes from the actions of the Saxon chieftain Beda around the sixth century, who either created a fording point on the river where the town now lies or developed a new settlement on the north bank of an existing crossing, very little, if anything, is actually known about him.

The Anglo-Saxon invaders were attracted to Bedfordshire because of its abundant water supply and suitability for agriculture. Between AD 500 and AD 850, what would become England was divided into a series of seven separate Kingdoms known as the Heptarchy. They included East Anglia, Mercia, Northumbria, Kent, Wessex, Essex and Sussex. Over the years, each would experience supremacy and subjugation. However, by the year AD 796, the kingdom of Mercia, or Middle Angles, which stretched from the River Humber in the north to the Tamar in the south-west, became the dominant force in England. The county of Bedfordshire, which would not be referred to as such until much later in AD 1011 when Bedford became the county town, would eventually emerge from the Kingdom of Mercia. A Bedfordian from these times – by association at least as he is thought to have been buried in a chapel in Bedford (or at least a place by the name of 'Bedeford') – is the Mercian King Offa who reigned for nearly forty years, beginning in AD 757. A powerful leader, his name survives in geographical terms in the extensive earthwork known as Offa's Dyke, built as a defence along the border of Mercia with Wales, whose kingdoms and leaders Offa was frequently in conflict with.

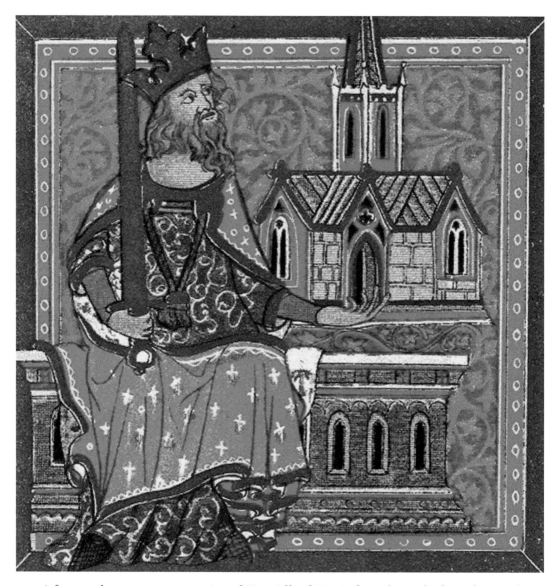

A fourteenth-century representation of King Offa of Mercia from the *Book of Benefactors of St Alban's Abbey*.

Throughout the ninth century, England was continuously raided by the Danes, and one by one the English kingdoms fell under the yolk of Viking power. The Danish chieftain, or 'jarl', Thurcetel made Bedford his headquarters, but like the Romans before them, the Danes did not have it all their own way. The English were to recover most of Bedfordshire during the reign of King Edward the Elder (899–924), the son of Alfred the Great. It was King Edward's son and heir, Athelstan, who was king of the Anglo-Saxons from 924 to 927 and king of the English from 927 to 939, who recovered all of England from the Danes.

He is regarded as the first king of England and one of the greatest Anglo-Saxon kings. During a visit to reoccupied Bedford, Edward fortified the town against future attack, creating a defensive moat on the south side of the river, known as the King's Ditch, parts of which survive between Cardington Road and Rope Walk. The Danes, however, were to return and the town was eventually overrun. In 1016, King Cnut laid waste Bedfordshire, becoming King of England and joining the country to a Scandinavian empire. It was not until 1042 that the Saxon line was restored, bringing about only twenty years of peace before the start of the Norman invasion.

The Conquest of 1066 brought about the creation one of the town's great landmarks. The Normans built a substantial motte-and-bailey castle, which in its completed form extended over a large area. The outer bailey covered a large tract of land bordered on the westward side from the line of the present-day High Street across to Castle Lane, and extending northwards from The Embankment up to the line of Castle Road and Ram Yard. The inner bailey then filled in the gap eastwards up to what we know today as Newnham Road.

Two sieges took place here, the first in 1137 and the second in 1224. A notable Bedfordian family from these times was the Beauchamp family. Hugh de Beauchamp was a leading Bedfordshire baron with manors in over thirty villages including Keysoe, Riseley, Aspley Guise and Stotfold. His grandson Miles de Beauchamp suffered the first siege of Bedford Castle by Stephen, a cousin of Henry I's daughter Matilda during a period of civil conflict. The de Beauchamp's retained control of the castle but later it was seized by the French mercenary Sir Falkes de Breauté, a henchman of King John. Following the two-month siege, during which Sir Falkes fled to Wales, Henry III's soldiers finally stormed the castle and the defending garrison, including Sir Falkes de Breauté's brother William, were hanged. Falkes himself surrendered and is thought to have been poisoned in exile.

The site of the former keep of Bedford Castle, a familiar Bedford landmark, as seen from The Embankment. (CastlesFortsBattles.co.uk)

DID YOU KNOW ... ?

Part of the tower of the Church of St Peter de Merton with St Cuthbert contains masonry dating back to Saxon times. One section of carved stone features two dragon-like creatures. The image of two battling dragons, in some cases a representation of the warring between the English and the Welsh, was a familiar Anglo-Saxon symbol.

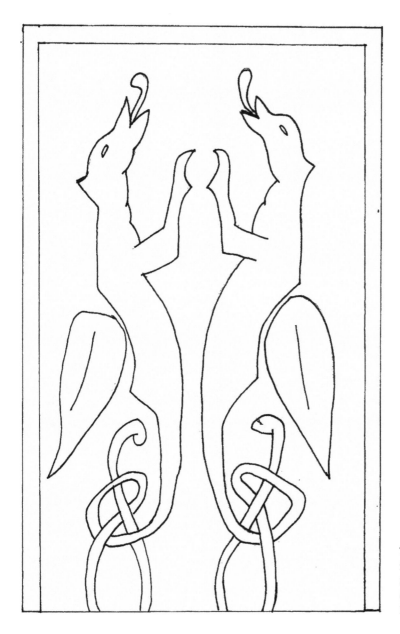

The Saxon dragons from the tower of St Peter's Church. (Drawing by Hannah Robertson)

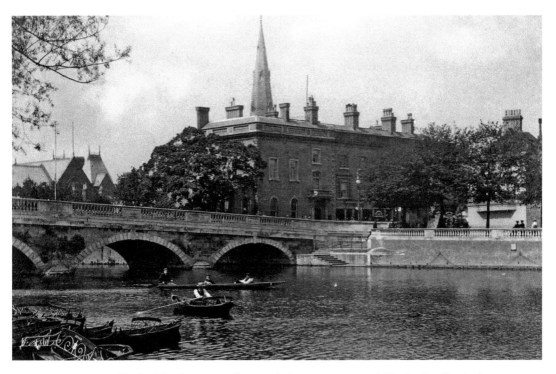

Rowing near Bedford Bridge from an early twentieth-century postcard. (Author's collection)

Major events in the country's history came and went, including the Wars of the Roses, the Dissolution of the Monasteries and the English Civil War. Gradually over the years the town of Bedford and its people began to grow. Wool manufacture was the main industry during the Middle Ages; later lace making and brewing came into prominence. During the 1700s the navigation of the Great Ouse from the Wash up to Bedford Bridge made the town an important trading centre, and a location for the county gaol, the infirmary and the asylum. The nineteenth century saw the arrival of gas lighting in 1832 and the railway in 1846. However, by the turn of the century, a town that is now recognisable to today's Bedfordians had arrived, and much of this book is concerned with Bedford's twentieth-century secrets, a world that is still well within living memory.

DID YOU KNOW ... ?
Bedford has had its share of extreme weather over the years. On the afternoon of 19 August 1672, during the reign of Charles II, the town was struck by a powerful storm which appeared from nowhere and terrorised the inhabitants before abating as suddenly as it had begun. Some idea of the ferocity of the incident can be judged

from part of the following account, *A True Relation of What Happened in Bedford*, which was written down shortly afterwards and published in pamphlet form:

> *We have unwonted news from these parts to acquaint you with. For on Munday last, the Nineteenth of this instant August, hapned in our town of Bedford, an Horrible and Unheard of tempest, with much Terrible Thunder, Rain, and Lightning, to the general Amazement and Terror of all the Inhabitants, beginning about one a Clock in the Afternoon, and continuing for about half an hour; in which time it threw the Swan Inn Gates off the Hinges into the Street and after it had whirled them there, up and down, as if they had been a Foot-Ball, it brake them to pieces; It drove a Coach in the same Yard from the back gates up, almost to the Cellar door, which is several Poles from thence; It carried a great Tree from beyond the River, over our Paul's Steeple, as if it had been a bundle of Feathers; it threw down Mr. Beverleys Stack of Corn of well-nigh Threescore Load, breaking to pieces the Carts that were under it, much of the Corn being carried no Man knows whether ... It is reported by Passengers upon the Road, that they see a great combustion in the Air, the Clouds as it were fighting one against another, in so much, that they thought at a distance the Town of Bedford was on a light fire.*

Despite the severity of the storm, reports of injuries were slight, although reports of similar devastation extended for several miles outside of the town out as far as Woburn.

Another calamity, this time created by fire rather than wind, took place in Bedford in 1802. A fire in a cottage in the St Loyes area of the town quickly took hold and spread to surrounding buildings. In total, seventy-two cottages were completely destroyed in a conflagration similar to the Great Fire that struck the Old Town High Street in nearby Stevenage five years later.

Following on from the fire of 1802 was the Great Flood that took place during the reign of George IV. On 1 November 1823, the River Great Ouse burst its banks, swamping the countryside for several miles inland. Some indication of the extent of the flood can be seen on the stone marker on the side of the former Phoenix public house in St John's Street where the water level reaches to the height of a man above the pavement. There are two other markers outside of the town, one on the bridge over the Great Ouse at Great Barford, and the other on Oakley Bridge. More flooding hit the region in the early years of the twentieth century when the Great Ouse burst its banks again on 30 April 1908. Some idea of the level of the water can be judged from contemporary photographs of the time. The waters rose again in post-war Bedford when, in mid-March 1947 following heavy winter frosts and then blizzard conditions, melting snow caused the Great Ouse to rise nearly 2 metres above its normal level, swamping surrounding roads and cutting off several villages. A chiselled mark showing the high water mark can be seen on the side of Bedford Bridge.

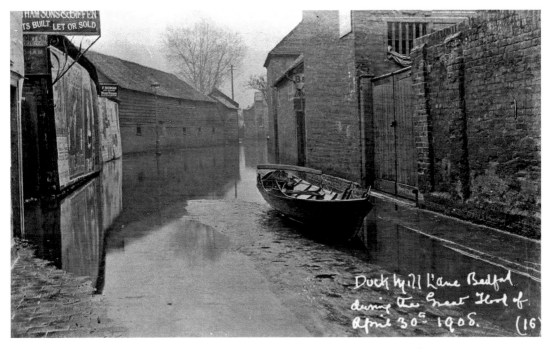

A view of Duck Mill Lane during the Great Bedford Flood of 1908. (Author's collection)

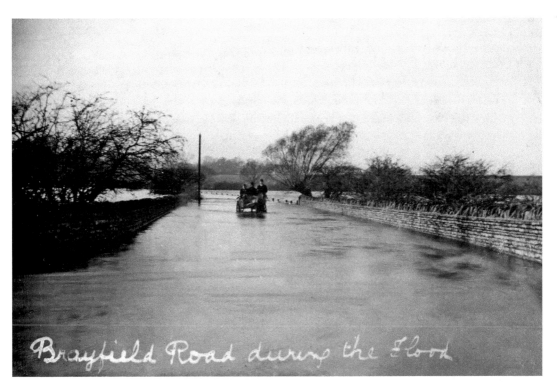

High water at Olney during the Great Bedford Flood of 1908. (Author's collection)

# 2. Wartime Bedford

The Victoria Cross was introduced by its namesake Queen Victoria on 29 January 1856 to acknowledge acts of bravery and heroism during the Crimean War. During the First World War, the Victoria Cross (or VC), still the highest honour bestowed by the country awarded for acts of valour, was awarded to 627 recipients. One of these was William Billington, a Bedford lad whose family had strong links to the town and who has an interesting and touching story.

William Billington was born at No. 51 St John's Street on 29 March 1886, and his early life was one of hardship and sadness. Following the death of his father (also named William) when he was very young, his mother, Annie Billington, experienced great difficulties in raising the family. William and his infant brother Frederick were separated. Frederick went to live in Bedford with his grandparents while William was sent to the Bedford Union Workhouse in Kimbolton Road. The building (once used as the North Wing of Bedford General Hospital and now Grade II listed) survives and is part of the present-day Bedford Health Village. Conditions at the time young William was there were decidedly grim, as a report prepared by the *British Medical Journal* and published in 1895 makes clear:

> The nursery is a miserable little room on the ground floor ... the investigators stated, "Here we found six or more infants in the care of an old pauper assisted by one or two younger women ... The infants themselves were a sorry, sickly lot, evidencing that they do not received skilled care or attention. There were no toys, but then that hardly mattered, for there was no space for play."

From Bedford, William Billington moved to Leicester where he was briefly reunited with his mother, who had remarried, and he took on the new family name of Buckingham. He was raised in the then recently established Countesthorpe Cottage Children's Home and later began training as a tailor, but on 29 November 1901, aged fifteen, he made the decision to enlist in the Royal Leicestershire Regiment. As William Buckingham, his military career with 'The Tigers' took him overseas where he served in Guernsey, Egypt and India. Following the outbreak of war in 1914, Buckingham and the rest of the 2nd Battalion were sent to the front line. The young soldier had a prophetic outlook on his future, remarking to a fellow resident of the Countesthorpe Cottage Home that he would either 'win the VC or get killed'.

In mid-March 1915, during the Battle of Neuve Chapelle, Buckingham risked his life on several occasions as he rescued injured soldiers and administered first aid, all the time being under heavy fire from the enemy. Eventually he himself was wounded and

subsequently evacuated back to England. Buckingham was awarded the Victoria Cross for his gallantry, and on 4 June 1915 was presented with his medal by King George V at Buckingham Palace. He was one of ten soldiers from Neuve Chapelle, including men from the Rifle Brigade, the Grenadier Guards and the Sherwood Foresters, who were decorated with the VC for the valour they had shown during the battle.

Sadly for William Buckingham, fate was to give him no choice where his future was concerned. Despite winning his Victoria Cross, the second part of his ultimatum also came true when on 8 April 1916 at Ginchy he was shot and killed while attempting to go to the aid of a wounded soldier. Like many First World War soldiers, his body was never recovered. Today, William Buckingham's Victoria Cross, held for many years by the Countesthorpe Cottage Home where he grew up, is exhibited at the Royal Leicestershire Regiment's museum in Leicester. A plaque dedicated to his memory can be seen on the site of his birthplace and brief family home in St John's Street, now replaced with a furniture showroom.

German prisoners captured during the Battle of Ginchy, where William Buckingham was killed in the First World War.

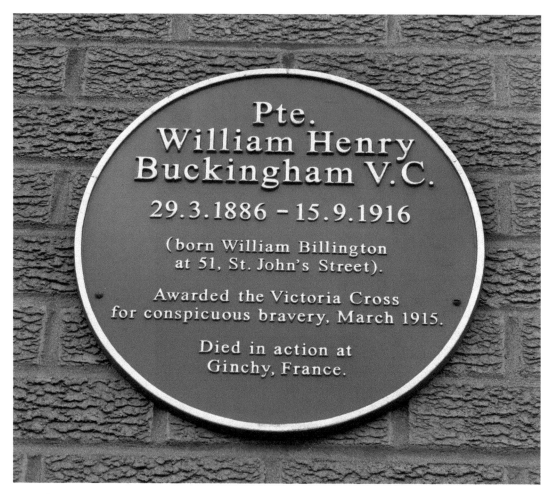

The plaque dedicated to the memory of William Buckingham VC on the site of his former home in St John's Street. (Paul Adams)

Bedford during the Second World War was little different to many towns affected by the conflict: men left to fight and many never returned; there were bombing raids and rationing. However, one aspect of Bedford's role in the war effort has remained a secret until very recent times. This is its connection with espionage and the clandestine efforts made to intercept, translate and utilise coded enemy radio signals.

The work (code-named 'Ultra') carried out at Bletchley Park, a large country house near Milton Keynes, involving the interception and decryption of German radio messages is now well known, although even as late as the 1970s it was still shrouded in much secrecy. This highly specialist activity was made possible by the use of a captured German 'Enigma' code-making machine. Between Bedford and Luton at Chicksands Priory was an RAF 'Y' Station, which intercepted German radio messages; the Meteorological Office at Dunstable also picked up enemy communications, which were transcribed and sent by motorcycle courier to Bletchley Park to be decoded.

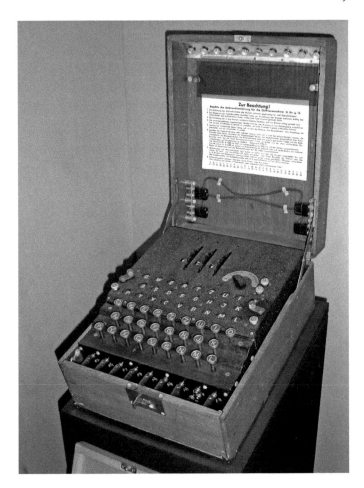

An Enigma machine from the Imperial War Museum in London. Second World War code-breakers at Bletchley Park discovered its secrets and were able to intercept and translate enemy communications. (Karsten Sperling)

The Special Operations Executive (SOE), also known as the Inter-Services Research Bureau or ISRB, was the wartime government department established to coordinate resistance to German forces on the European mainland. It did this by supplying freedom fighters in France and other occupied countries with equipment, arms and provisions, as well as carrying out spying missions, sabotage and other activities including assassinations. Bedford's geographical location, close enough to London to make travel between departments in the capital relatively straightforward but with outlying rural areas suitable for clandestine operations, made it ideal for SOE purposes.

With the entry of Japan into the war in December 1941, it became essential that Japanese coded messages could be intercepted and translated as well as German ones. With this specific intention, SOE established a training facility in Bedford town centre where recruits were given training in both linguistics, cipher-breaking and the creation of code books. This was located on the first floor of Ardour House above the Gas Board showroom on the corner of The Broadway and Dame Alice Street. Officially designated as the Inter-Service Special Intelligence School, it became known, unofficially, as The English School of Cryptography and also (not surprisingly) as the 'Spy School'.

The former gas showroom where SOE code-breakers were trained during the Second World War. (Paul Adams)

DID YOU KNOW ... ?
Leo Marks (1920–2001), the code-breaker who trained at the Bedford 'Spy School', was also a screenwriter who wrote the script for Michael Powell's controversial 1960 thriller *Peeping Tom*. Now a cult film, it features Carl Boehm (son of the Austrian conductor Karl Boehm) as a voyeuristic serial killer who records the dying moments of his victims on a hand-held movie camera. Marks based many of the characters in the script on customers at his father's antiquarian bookshop in Charing Cross. He is also known for his poem *The Life That I Have* (1943), which was used by the SOE agent Violette Szabo (1921–45).

The tutor assigned to teach Japanese at the Inter-Service Special Intelligence School was Oswald Tuck (1876–1950), a former employee in naval intelligence at the Admiralty who had learnt Japanese while on shore leave in the Far East during his time in the Royal Navy. During the course of the war the 'Spy School' expanded and other premises were taken over for espionage work. These included No. 7 St Andrew's Road, No. 52 De Parys Avenue and No. 1 Albany Road. Most likely students both lived and studied at these addresses. Those who passed the grade were then transferred to continue the war effort at Bletchley Park.

DID YOU KNOW ... ?

What appears to be the only recorded incident of a member of the Home Guard exchanging small arms fire with the enemy on the British mainland during the Second World War took place near Bedford. This was in 1943 and the private involved was awarded the British Empire Medal for his actions.

There were at this time a number of POW camps across Bedfordshire for Italian and German prisoners. They worked on the land, clearing ditches and harvesting crops. Camps were sighted at, among other places, Stewartby, Houghton Conquest, Clapham and Milton Ernest. On 9 July 1943, twenty-five-year-old Private Charles Hands of the Pioneer Corps, and originally from Liverpool, was guarding a work party of seven Italian prisoners from the Ducks Cross camp at Bolnhurst who were cutting hedges on the edge of a field near Tilbrook. One of the prisoners, Antonio Amedeo, suddenly attacked Private Hands, who was brutally killed with a hedging hook. Amedeo seized the dead man's rifle and several rounds of ammunition and made his escape into a large area of overgrown forest at Kimbolton Park. The Bedfordshire and Huntingdonshire Home Guard were quickly alerted and a search of the surrounding countryside ensued.

Two members of the Home Guard who took part in the hunt for Antonio Amedeo were Bernard Shelton and his eighteen-year-old son John, both from Grange Farm, Pertenhall. When the search was called off for the day towards evening, the two men returned home. Around six o'clock, young John Shelton got up from his seat in the sitting room with the intention of giving the farm chickens their evening feed. Luckily for him he took his Home Guard issue rifle with him, for as he stepped out into the passageway he came face to face with the Italian fugitive who had earlier crept into the house unseen (leaving his boots outside the dairy window) and helped himself to food from the larder. Startled, Amedeo raised Private Hands' rifle and fired, but despite the close quarters his shot missed its target and, finding it impossible to reload quickly enough, he immediately fled up the stairs into the upper part of the house.

Bernard Shelton quickly joined his son, and similarly armed, they gave chase using a second staircase. Amedeo was quickly discovered holed up in one of the bedrooms and the two Sheltons immediately opened fire, killing the fugitive instantly. Later the same year, John Shelton was awarded the Military Division's British Empire Medal for gallantry. It was suggested at the time that the Italian had become enraged when his request to speak to a party of girls from the Women's Land Army working in a nearby field was turned down, but ultimately the real reasons for Amedeo's actions in killing Private Hands in July 1943 remain a mystery.

One of the most remarkable Bedfordians engaged in secret war work between 1939 and 1945 was Cecil Vandepeer Clarke (1897–1961). Although born in London, Clarke, by profession a mechanical engineer, moved to Bedford in 1919 where he took on the directorship of the H. P. Webb & Co. Ltd motor manufacturing company. A First World War veteran, he had served with the British Expeditionary Force in France and had won the Military Cross for his role in the Battle of Vittorio Veneto in Italy during the closing months of the conflict.

In the mid-1920s, Clarke established his own engineering firm at premises in Tavistock Street, on the corner junction with Park Road West – the site is now a petrol station. By 1937, his unorthodox design for a motor caravan and trailer had brought him to the attention of Stuart Macrae, an engineering and science magazine editor. Following the outbreak of hostilities in September 1939, Macrae was enlisted into military research for the War Office and quickly realised that the Bedford engineer would be the perfect person to realise design solutions to engineering projects involving weaponry, equipment and explosives.

Clarke joined the SOE as acting major and was sent to Aston House on the outskirts of Stevenage where, as at Bletchley Park, a large remote house had been requisitioned, in this case for the development of saboteur and espionage equipment. He designed a

The Bedford engineer Cecil Vandepeer Clarke (1897–1961) who designed limpet mines and other secret military hardware for the SOE. (Bernard O'Connor)

magnetic limpet mine used by commando frogmen to sink enemy ships together with a hand-held mortar, the 'spigot gun', which could be parachuted to resistance fighters on the occupied mainland and used to destroy vehicles and tanks at close range by being attached to the trunk of a tree.

Of all Cecil Clarke's contributions to the war effort, his involvement with Operation Anthropoid is perhaps the most interesting and dramatic. With the support of the Czechoslovak government, which at the time was in exile in England at Aston Abbots in Buckinghamshire, the SOE instigated and set in motion a daring plan to assassinate Reinhard Heydrich, a high-ranking Nazi who held various positions in Hitler's regime. Now considered one of the major architects of the Holocaust, Heydrich was in overall control of occupied Czechoslovakia and had beaten down all resistance with an iron fist. Code-named 'Anthropoid', the mission was carried out by two Czech soldiers, Jozef Gabčik and Jan Kubiš. Cecil Clarke and another SOE technician, Capt. Leslie Cardew-Wood, designed a hand-held mine (based on an existing hand grenade) that would be suitable for use in an ambush, and the two Czechs were trained in its use in the grounds of Aston House.

On 27 May 1942, the attack took place as Heydrich drove in an open staff car through the streets of Prague. Kubiš detonated the mine designed by Clarke and Cardew-Wood in close proximity to Heydrich's car, and as a result he died of his injuries nine days later. In the ensuing manhunt, both Kubiš and Gabčik were killed and there were savage reprisals made against the Czech people. The event remains a pivotal point in the resistance of occupied Czechoslovakia against the German invaders, with Cecil Clarke, the mild-mannered engineer from Bedford, having an important role in the death of the most senior Nazi to be killed by assassination during the Second World War.

Aston House near Stevenage, now demolished, where secret war work took place including the preparations for Operation Anthropoid. (Des Turner)

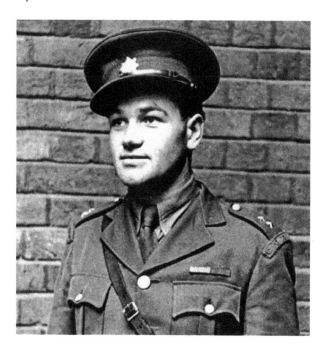

Czech soldier Jan Kubiš (1913–42), who was trained by Bedford engineer Cecil Clarke to carry out Operation Anthropoid.

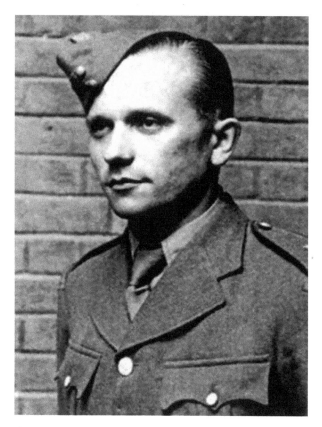

Jozef Gabčik (1912–42), one of several Czech resistance fighters who lost their lives following the assassination of Nazi SS Obergruppenführer Reinhard Heydrich.

# 3. Musical Bedford

Music making has a long and enthusiastic history in Bedford. An early organisation was the Harmonic Society, a private music club that began in the pre-Victorian era before disbanding in the mid-1850s. In 1867, the Bedford Amateur Musical Society began giving concerts, initially choral performances which later included orchestral pieces including symphonies by Haydn. Its first music director was Philip Henry Diemer (1836–1910), a local Bedford man who had studied at the Royal Academy of Music in London. On 16 April 1874, a double concert took place to celebrate the official opening of the new Corn Exchange, which had taken place the previous day. Handel's *Messiah* was given along with Beethoven's *First Symphony*. In 1880 and reflecting the high quality of performance, the ensemble became the Bedford Musical Society and performed as such until 1933. Following a lengthy hiatus, the BMS resumed concert giving in 1941, becoming the Bedford Choral Society in 1988.

As well as orchestral music, the brass band has also been well represented from the same early period and continues to this day. On 4 May 1894, the Bedford Town Band, formed from an earlier ensemble, the Wesleyan Band, gave its first performance at a fête in Cardington Road and became a regular and popular contributor to public events. The Town Band, also known as the Bedford Town Silver Prize Band, played to celebrate the Diamond Jubilee of Queen Victoria on 22 June 1897, often, as then, performing on a floating platform moored close to the Embankment. This proved on one occasion to be the band's undoing when in 1923 during the preparations for a Whit Monday concert, the platform sank as the bandsmen were boarding with several musicians and instruments ending up in the river. For a period before the Second World War the band was known as the Bedford Trades Band, with close connections to the Working Men's Club in Ashburnham Road. Following the end of the war, the Trades Band became the Town Band again under the conductorship of Reginald Crane who led performances up until the early 1970s.

Despite the upheaval, disruption and tragedy that the outbreak of hostilities in 1939 ultimately brought to the British Isles, the war years were to see one of the richest periods in the musical life of Bedford. This was due in no small part to the residency of the BBC Symphony Orchestra, which made the town its wartime home, making great use of the Corn Exchange, the Great Hall at Bedford School and several other locations for both rehearsal and performance. The BBCSO's chief conductor was Sir Adrian Boult (1889–1983), knighted in 1937 for his services to British music, whose many recordings are still greatly admired today.

Following evacuation from London, the BBCSO initially relocated to Bristol, but by the summer of 1941 continued bombing of the city proved both disruptive and dangerous. Boult was adamant that the orchestra needed to continue its morale-boosting work, citing

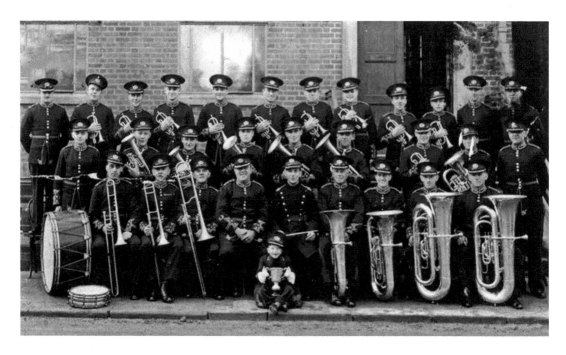

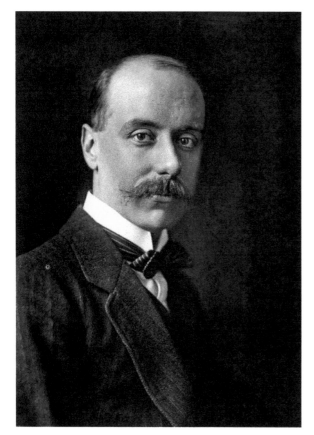

*Above*: The Bedford Trades Band, an early post-war incarnation of the Bedford Town Band, with their conductor Reg Crane, photographed outside the Trades Club in Ashburnham Road. (Colin Crane)

*Left*: Sir Adrian Boult (1889–1983), principal conductor of the BBC Symphony Orchestra, which made its home in Bedford during the war year.

the fact that over in Nazi Germany the Berlin Philharmonic was still broadcasting at its pre-war strength. On 30 July 1941, the full orchestra travelled east to Bedford by train, all except its conductor, who elected to make the journey by bicycle. Two hotels in Bushmead Avenue were used as permanent billets for the musicians during their stay in the town.

DID YOU KNOW ... ?
Sir Henry Wood, conductor and founder of the famous Proms concert series, conducted at Bedford many times. On 13 July 1944, Wood conducted the BBC Symphony Orchestra in a Bedford studio broadcast of the British premiere of Dimitri Shostakovich's epic *Symphony No. 8*, written as a testament to the pain and suffering inflicted on the Russian people during the course of the German invasion. Sir Henry gave his last public performance at the Corn Exchange. He died in Hitchin Hospital on 19 August 1944.

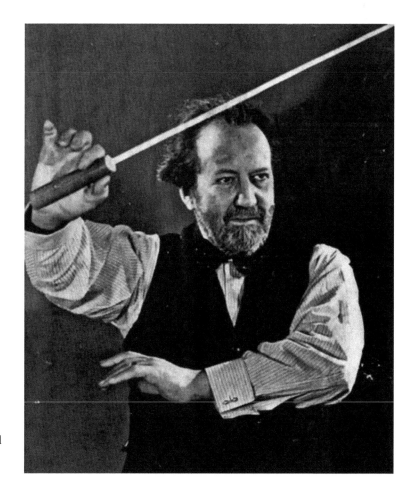

The noted conductor Sir Henry Wood (1869–1944), who brought the famous Proms to Bedford during the Second World War. (Author's collection)

Wartime concert-giving by the BBC Symphony Orchestra began at 7.00 p.m. on 17 September 1941. All the main concerts were given in the Corn Exchange, but there were six other locations around the town that were also used for performance and for the running of the orchestra. The Theatre Orchestra was based in St Paul's Mission Hall, now a lost building that was located behind the former almshouses on the corner of St Loye's Street and Allhallows Lane. Musical instruments were stored in the basement air-raid shelter at the Bunyan Sunday School in Castle Lane. It was here that a small studio was also established for talks and recitals. The old Castle Billiard Hall, also in Castle Lane and now part of the Bedford Gallery, was used by the BBC Singers, a two-octet group that divided light music and less-standard repertoire between them. Another small studio was established in Queens Park at the Gas Works Social Club's Co-Partners Hall off of Nelson Street. The BBC's religious department was based in the Trinity Chapel in St Paul's Church and it was here that the daily 'Somewhere in Britain' service was broadcast. As well as the Corn Exchange, the BBCSO's other main studio was in the Great Hall at Bedford School. It was here in August 1944 that Boult and the orchestra made a highly regarded commercial recording of Elgar's *Second Symphony*. The BBCSO stayed in Bedford for the remainder of the war, eventually returning to London in September 1945.

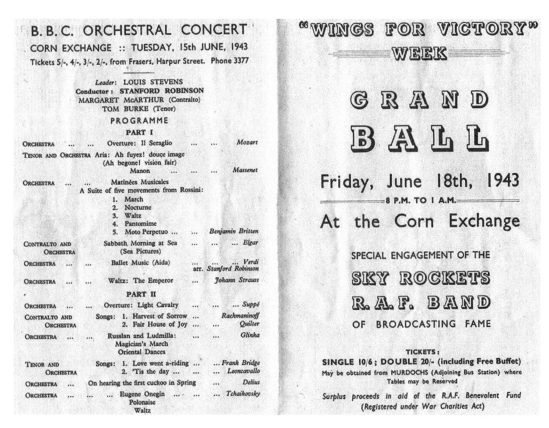

Programme for BBC Symphony Orchestra 'Wings for Victory' concert at the Bedford Corn Exchange on 18 June 1943. (Colin Crane)

**DID YOU KNOW ... ?**

The familiar saying 'Up the wooden hill to Bedfordshire' first appears in a book of memoirs by George Sturt of Farnham, Surrey, published in 1927 as *A Small Boy in the Sixties*. Only a few years later, the phrase was used by lyricist Nixon Grey and orchestral leader Reg Connelly and their popular song 'Up the Wooden Hill to Bedfordshire' was recorded by Connelly on 31 January 1936 with dance band singer Elsie Carlisle (1896–1977) as soloist. The same year the song was recorded again, this time with organ accompaniment by (later Dame) Vera Lynne, who made her debut record with the piece.

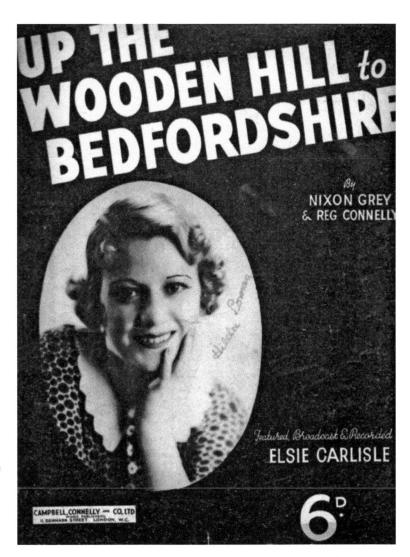

Cover of the sheet music for Grey and Connelly's light-hearted song 'Up the Wooden Hill to Bedfordshire' (1936), first recorded by Elsie Carlisle and later a debut piece for Dame Vera Lynn. (Alexandros Kozak)

A noted composer who made a wartime visit to Bedford was Sir Arnold Bax, knighted in 1937 and made Master of the King's Music in 1942. The occasion was the premiere recording of his *Violin Concerto*, which took place in the Corn Exchange on 23 February 1944. Sir Adrian Boult and the BBC Symphony Orchestra were joined by soloist Eda Kersey, who had premiered the concerto with the same orchestra the year before in a concert on St Cecilia's Day (22 November) conducted by Sir Henry Wood. Bax attended the recording sessions, spending most of his time in the mobile studio – a van parked outside which was heated to keep the wax discs soft and pliable. Tragically, Eda Kersey died suddenly at the age of forty the same year and the Bax concerto is one of only a handful of recordings of her violin playing that now exists.

Arnold Bax was one of several interwar composers including John Ireland and Gustav Holst who were associated with a new style of classical music that both used and was inspired by English folk song. The doyen of this pastoral school of English composition, famously derided by the modernist composer Elisabeth Lutyens as 'cowpat music', was Ralph Vaughan-Williams (1872–1958). His connection to Bedford is his Bunyan-inspired opera *The Pilgrim's Progress*, which was premiered at the Royal Opera House, Covent Garden, on 26 April 1951, conducted by Leonard Hancock. As early as

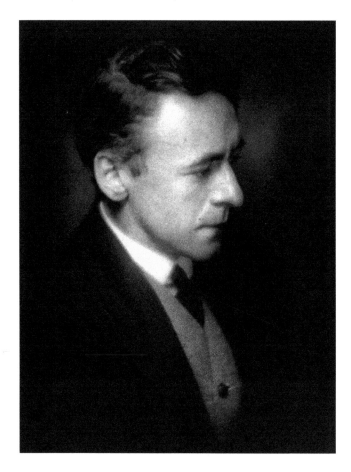

Composer Sir Arnold Bax (1883–1953), who came to Bedford for the recording of his *Violin Concerto* in 1944.

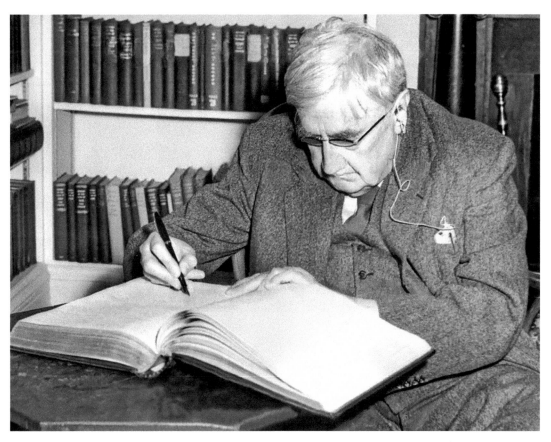

The English composer Ralph Vaughan-Williams (1872–1958) in later life. His opera *The Pilgrim's Progress* was premiered at Covent Garden on 26 April 1951.

1906, Vaughan-Williams had written music to accompany a dramatic performance of the Bunyan story which was performed at Reigate Priory in Surrey that year under the baton of the composer. Much later, in 1942, there was a wartime commission by the BBC for more music, this time to accompany a radio dramatisation. With this behind him, Vaughan-Williams set to work and composed what was to be his last opera, although it is his symphonies as well as other orchestral pieces such as *The Lark Ascending* for which he is most remembered and revered today. The premiere recording of Vaughan-Williams' *The Pilgrim's Progress*, which both opens and closes in the setting of Bedford Gaol, was made by the redoubtable Sir Adrian Boult and the London Philharmonic Orchestra and the Philharmonic Choir in 1971.

Ralph Vaughan-Williams was not the only English composer to be inspired by John Bunyan. In 1931, the now neglected composer Robin Milford wrote an Oratorio titled *Pilgrim's Progress*, while a large-scale work for soloists, chorus and orchestra on the same subject by Granville Bantock appeared three years before in 1928. In July 1909, Bantock's specially composed music to a performance of Sophocles' Greek tragedy *Electra* had been premiered at a performance at Bedford College.

DID YOU KNOW ... ?

The British premiere of Stravinsky's *Symphony in C* took place in Bedford's Corn Exchange on 17 November 1943. One of the most influential composers of the twentieth century, the Russian-born Igor Stravinsky (1882–1971) is famous for his groundbreaking ballet scores including *The Firebird* (1910), *Petrushka* (1911) and notably *The Rite of Spring* (1913). During the Second World War, the composer was in exile in America and it was here that the *Symphony in C*, a four-movement work lasting around half an hour, was completed. Stravinsky himself conducted the first performance in Chicago in November 1940. Sir Adrian Boult and the BBC Symphony Orchestra introduced the work to Britain during their 1943–44, season, which also included another work from America, Roy Harris' *Symphony No. 3*.

A look at the wartime musical side of Bedford would not be complete without at least a brief mention of the American musician Glenn Miller. Although his association with the town is well known, the enigma surrounding his final hours is well suited to the secret and at times mysterious side of Bedford's history.

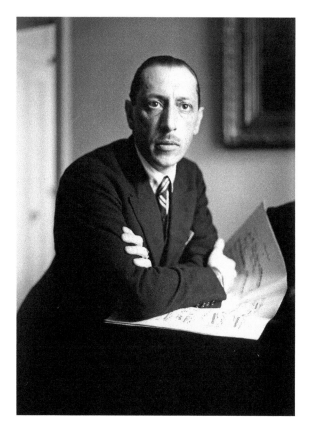

The Russian composer Igor Stravinsky (1882–1971), whose *Symphony in* C was given its British premiere in Bedford in 1943.

Born in Clarinda, Iowa, in 1904, Miller enjoyed a successful career as a trombonist, musical arranger and big band leader, with numerous hit tunes including 'In the Mood' (1939), 'Little Brown Jug' (1939), 'Pennsylvania 6-5000' (1940) and 'American Patrol' (1942). Following America's entry into the Second World War, Miller volunteered for army service in order to boost morale and entertain the American troops. He was awarded the rank of captain and was soon transferred to the Army Air Forces. Miller formed a fifty-piece ensemble, the Army Air Force Band, which broadcast weekly on the 'I Sustain the Wings' radio programme for which Miller co-wrote the theme tune. Promoted to the rank of major, Miller and his musicians subsequently travelled to England, initially locating in London before moving permanently to Bedford. Miller himself was billeted at the old Pilgrim's Progress pub, requisitioned for use as the American Red Cross Officers' Club, while two large houses in Ashburnham Road were used by the band themselves. The Army Air Force Band under Miller's direction gave the first of many Bedford performances at the Corn Exchange on 9 July 1944. Actor David Niven (1910–83), famous for his roles in films such as *A Matter of Life and Death* (1946) and *The Guns of Navarone* (1961), and then a serving soldier with the rank of lieutenant-colonel, introduced the musicians to the audience.

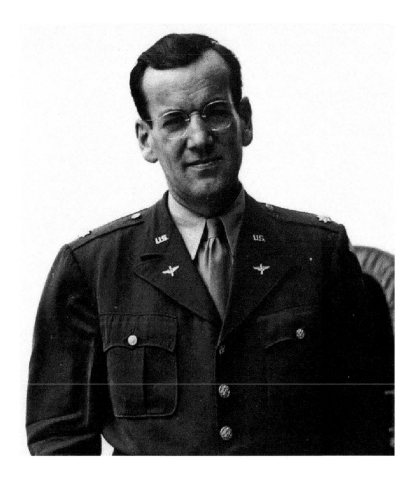

The American musician Glenn Miller (1904–44), who gave many performances in Bedford and whose life ended in mystery.

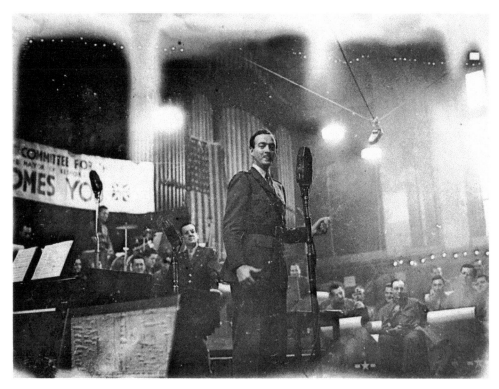

David Niven introduces Glenn Miller and his band to a wartime audience at the Corn Exchange in July 1944. (Dennis M. Spragg, Glenn Miller Archive, University of Colorado Boulder)

During the war many big names in entertainment including Bob Hope, Bing Crosby, Marlene Dietrich and Dinah Shore gave concerts to entertain the troops. *Gone with the Wind* actor Clark Gable, himself a serving observer-gunner with the 351st Bomber Group at RAF Polebrook, also visited the town. Valerie Harper-Skelton remembers her mother describing an occasion serving Gable with a cup of tea from the tea urn at the American Red Cross Club and the sugar bowl was empty: 'Never mind, honey,' Gable quipped in true Rhett Butler style, 'Just put your little finger in it and it'll be sweet enough.'

Towards the end of 1944, Miller made plans to travel to France to entertain the troops in liberated Paris. For the majority of the war years, Twinwood Farm at Clapham, on the northern outskirts of Bedford, was used as an RAF night fighter base, and it was from here that Miller and his travelling companion, Lt-Col Norman Baessell, took off, travelling ahead of the Army Air Force Band to make preparations for their forthcoming concerts. On the afternoon of 15 December 1944, the single-engine USAAF UC-64 Norseman plane rose into the cold winter sky over Bedford, and Major Glenn Miller was never seen again.

The famous bandleader's disappearance was announced on Christmas Eve and since then there have been numerous theories as to what happened on that day in 1944. Although the most likely explanation is that the plane suffered engine failure due to the cold weather conditions and crashed into the English Channel, conspiracy theorists have

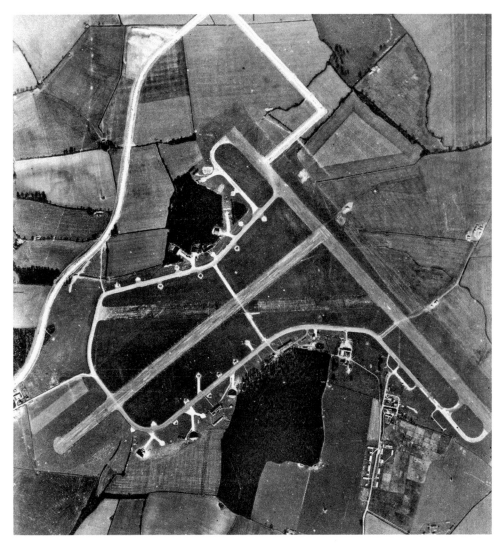

Aerial view of RAF Twinwood on the outskirts of Bedford, where Major Glenn Miller took off on his last flight on 15 December 1944.

suggested otherwise. At one time or another Miller is said to have died in a Paris brothel, faked his own death in order to avoid being exposed as both a black market racketeer and a German spy, eloped with a secret lover, and been tortured to death by the Nazis after his part in a secret American plot to overthrow Hitler was discovered by the Gestapo.

Despite the mystery surrounding the disappearance of Glenn Miller, today a familiar statue commemorating his wartime performances – sculpted by Patricia Finch and unveiled by the then Mayor of Bedford, Councillor Derek Alan Jones, on 15 December 1994, the fiftieth anniversary of the bandleader's disappearance – looks out from the façade of the Corn Exchange where the Army Air Force Band concerts took place.

DID YOU KNOW ... ?
The sculptor Patricia Finch (1921–2000), who created the commemorative bust of Glenn Miller, was the winner of the Gold Medal for Sculpture in Venice. As well as the highly regarded *Mother and Child* statue outside Great Ormand Street Children's Hospital, she sculpted several international figures including the deposed Colonel Gadhafi of Libya and King Hussain of Jordan. In 1976, she sculpted the head of writer and ghost hunter Peter Underwood (1923–2014), who knew Bedford well and carried out the first 'official' investigation into a haunted house at Aspley Guise in 1947 on behalf of Luton Council. As a precursor to the next chapter, not only is RAF Twinwood Farm said to be haunted, but it has also been suggested that the ghostly music, heard in the old 'B' hangar at the former RAF Nuthampstead in nearby Hertfordshire, is that of Major Miller himself, who is known to have performed there.

The award-winning sculptor Patricia Finch (1921–2000) in her studio in the 1960s. (Lucie Skeaping)

Classical music is still well represented in Bedford today. Founded in 1967, the Bedford Symphony Orchestra gives regular performances, as does the Bedford Sinfonia, which came into existence in 1972. Another group still performing is the Bedford Music Club, which in past years hosted an impressive roster of guest musicians. Artists who visited Bedford to perform with the BMC included mezzo-soprano Dame Janet Baker (1976 and 1982), guitarist Andrés Segovia (1976), and the pianists Vladimir Ashkenazy (1979) and Dame Moura Lympany (1983). Not everything went according to plan, however. David Williams, a former long-time music teacher at Bedford High School and double bass player in the Bedford Symphony Orchestra, remembers a visit by the Russian father and daughter pianists Emil and Elena Gilels, who performed piano duets for the BMC in 1981. Williams remembers Gilels making a striking entrance into the hall looking like a cross between a Soviet diplomat and the Commendatore from Mozart's *Don Giovanni*, and the impression continued during the recital that followed.

The Russian pianist Emil Gilels (1916–85), who performed for the Bedford Music Club in the 1980s. (Author's Collection)

In October 1984, shortly before his death, Emil Gilels returned to Bedford to give a solo recital where potential disaster awaited. In the concert programme, a portrait of the German baritone Dietrich Fischer-Dieskau had been accidentally used in place of one of the Russian maestro. Shrugging off this faux pas, Gilels commenced his performance. However, during a delicate piece by Debussy, the audience watched in growing horror as a wire supporting a microphone suspended above the stage began unravelling, dropping lower and lower until finally it came free and crashed down onto the floor in front of the piano. Gilels carried on regardless. 'What he thought of Bedford,' David Williams remarks, 'I don't know!'

The popular music revolution of the 1960s brought about a new aspect to Bedford's musical life with new artists making appearances and in turn inspiring local talent. The Granada Cinema in St Peter's Street, originally built in 1934 as a major picture palace but also equipped with a stage and orchestra pit for live performances, saw many visiting 'pop package' tours. The late 1950s saw, among others, Lonnie Donegan, Eddie Calvert, Cliff Richard and Petula Clarke take the stage, and by 1962 the roster had grown to include acts including Adam Faith, The Shadows, Tommy Steel, Frank Ifield and Gene Vincent. The concert on 6 February 1963 was a notable date as main act Helen Shapiro, whose chart hits included 'You Don't Know' and 'Walkin' Back to Happiness', was supported by The Beatles on what was the third date of their first nationwide tour. Other artists who played at the Granada right up until the end of the 1960s included Johnny Cash, The Kinks, Herman's Hermits and guitar legend Jimi Hendrix. The Corn Exchange also saw performances by bands such as Brian Pool and the Tremolos, The Mersey Beats, Eden Kane, the Pretty Things, Shane Fenton and the Fentones (who later became Alvin Stardust), Cream and The Who.

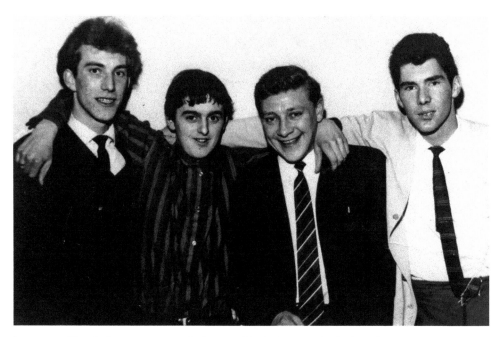

'Beat Boom' band The Living Legends from Bedford photographed after playing a support slot at the Corn Exchange in 1964. (Colin Crane)

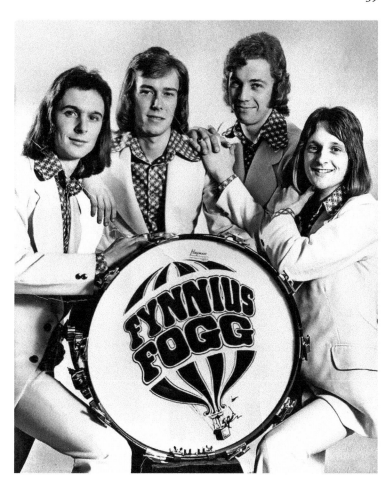

Local Bedford band Fynnius Fogg, who played over 600 gigs during the 1970s and released a single with Pye on their Dawn label. (Bernard Hewitt)

DID YOU KNOW ... ?

Paul McCartney gave an impromptu premiere of his newly finished song 'Hey Jude' on 30 June 1968 in the village of Harrold on the outskirts of Bedford more than a month before it was actually recorded. Returning to London from a trip to Yorkshire where he had been recording with The Black Dyke Mills Band, McCartney, together with Apple executive Tony Bramwell, decided to leave the M1 motorway and break their journey, choosing a village with what they considered to be the nicest-sounding name from the AA roadmap. Invited in for tea by a local family, McCartney picked up an acoustic guitar and sang several songs including a newly composed ballad written for John Lennon's young son, Julian. Later in the evening, the famous Beatle went to the Oakley Arms where he entertained the locals with several numbers played on the pub piano. 'Hey Jude', one of the most celebrated of Beatles songs, was recorded at the end of the following month and released as a single on 26 August 1968.

Paul McCartney giving an impromptu performance in the Oakley Arms in Harrold village on 30 June 1968. (Harroldvillage.co.uk)

As well as the Granada and the Corn Exchange, Bedfordians will remember several other venues around the town from the era of 1960s and 1970s live music making. The former Teacher's Training College in Goldington Road was a popular local gig venue frequented by bands such as Thin Lizzy and Mott the Hoople. In the early 1970s, Thursday nights at the Friars Club in the Addison Centre, Kempston, saw sets by Hawkwind, the Graham Bond Organisation with Eric Clapton and Jack Bruce, progressive rockers East of Eden, Free, Genesis and Van der Graf Generator. Bedford Town Football Club in Ford End Road was another venue visited by the likes of Marc Bolan and T-Rex, together with The Herd and Deep Purple.

# 4. Spooky Bedford

Whether you believe in ghosts or not, Bedford has several interesting connections with the mysterious world of the paranormal. The first of these concerns William Turner, who can be described as one of the country's first ever ghost hunters.

Born in 1833, Turner was a jobbing gardener who lived near the village of Oakley, and accounts of his life suggest that he had some mediumistic quality, or at least a degree of psychic intuition. He was highly regarded as a fortune-teller at village fêtes, and was known for the accuracy of his weather predictions and great (and it would seem unnatural) skill as a horticulturalist. As a young man he fought in the Crimean War and eventually lived to the advanced age of ninety-six.

William Turner's later years were spent visiting allegedly haunted places in and around Bedford and the county as a whole, and he had many unusual and decidedly paranormal encounters which he duly recorded in a notebook that was recovered after his death in 1929. Unfortunately corroborative statements, dates and other details of these cases (as well as the whereabouts of the notebook today) are lacking, so although impressive, many of his reported experiences must remain anecdotal in nature.

Turner appears to have been encouraged to look into the paranormal by his grandfather, who at one time was the landlord of The Old George inn at Silsoe. This building is reputed to be haunted by Lady Elizabeth Grey, at one time a local aristocrat whose family seat was the nearby Wrest House. Neither Turner nor his grandfather saw the ghost themselves, but it was apparently a well-known haunting and a workman at The Old George in 1960 is the last person to date who claimed to have seen the apparition.

William Turner's first ghostly encounter was in fact in another building in Silsoe – a house in Ampthill Road close to his grandfather's public house. While lodging with the owner, Mrs Hallam, Turner saw the fleeting apparition of a small barefoot girl wearing a pinafore dress who ran past him and disappeared close to his bedside. This is another haunting that has continued into modern times, as a later owner reported seeing the ghost, known as Sarah, to the *Luton News* in the late 1980s.

The Old George inn at Silsoe, where Bedford ghost hunter William Turner's grandfather was once the landlord. (Paul Adams)

DID YOU KNOW ... ?
Despite being Bedford's most famous ghost, the identity of the highwayman 'Black Tom' remains something of a mystery. A number of commentators including Luton ghost hunter Tony Broughall give 1607 as being the year that 'Black Tom' met his end on the town gallows, but there is no indication of who he actually was and where he came from. His ghost has been associated with Union Street for many years, often appearing in daylight. His last confirmed appearance was in 1963 when he was described as 'wavering about as if drunk with his head lolling on one side like a loose puppet'. On this occasion when approached, the figure of 'Black Tom' simply vanished.

Around 1870, William Turner recorded in his notebook his experiences while staying in a house in Ampthill. On this occasion he had been employed for several weeks to clear a large garden which had remained untended for several years as the house had lain empty. Here the ghost hunter reportedly heard on several occasions eerie sounds that seemed to be a re-enactment of a murder that took place in the building in the 1850s when fifteen-year-old Agnes Rumbelow was stabbed in the back with a sickle by an unknown assailant. Another of Turner's reported encounters, this time with a cyclical or recurring haunting, took place in an unnamed parish church near Milton Earnest. While visiting the church on a hot summer's day to view the stained-glass windows, Turner briefly saw a tall top-hatted figure, which he subsequently discovered was the apparition of a former vicar who appeared (in good ghostly tradition) every year on the anniversary of his wife's death.

'Black Tom' materialises. The ghostly Bedford highwayman is said to have gone to the gallows at the beginning of the seventeenth century. (Drawing by Hannah Robertson)

DID YOU KNOW … ?

One of the most important spiritualist mediums of the Victorian era has a close connection with Bedford. William Stainton Moses was born on 5 November 1839 in Donington, Lincolnshire, where his father was the headmaster of the local grammar school. When he was thirteen, the family moved to Bedford so that the young William could attend Bedford College. Although initially sceptical of spiritualism, Stainton Moses attended a séance with the American medium Lottie Fowler on 2 April 1872 and later the same year found he had mediumistic powers of his own. According to contemporary accounts, these included levitation, psychic lights, trance communication and automatic writing. In 1884, Stainton Moses became president of the London Spiritualist Alliance and edited their journal, *Light*, the longest-running spiritualist publication which still appears today. He also wrote several books on psychical subjects under the pseudonym 'M. A. Oxon'. Stainton Moses died at his mother's house in St Peter's Street on 5 September 1892 and is buried in the Norse Road Cemetery.

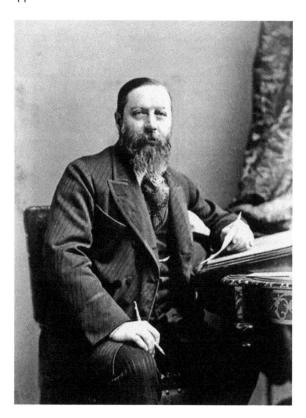

The celebrated Victorian medium
William Stainton Moses (1839–92),
founder of the spiritualist journal
*Light*. (Paul Adams)

The enormous twin hangars at Cardington on the south-eastern side of Bedford are perhaps the town's most immediate and recognisable landmark. They provide not only a link to the airship industry of former times, but also surprisingly give Bedford a close connection with the world of séances and the paranormal.

The Short Brothers engineering company began building the first (north) hangar in 1915 and it later underwent a two-year period of extension work beginning in 1924. The second or south hangar was originally constructed at the Royal Navy Air Service base at Pulham in Norfolk, and later dismantled and re-erected at Cardington. The *R100* and its sister ship, the *R101*, were designed to provide long-distance airship travel around the world. The *R100* was built in Howden in Yorkshire and its maiden flight on 16 December 1929 brought it to Cardington where it remained. On 29 July 1930, the airship set off for Canada and returned to Cardington in the middle of August. The *R101* took its first flight two months before its sister ship, a short voyage to London and back, and several test flights and publicity trips followed throughout the following year.

On the evening of 4 October 1930, the *R101* left Cardington bound for Karachi. In the early hours of the following morning, the airship crashed and burst into flames near the village of Beauvais in northern France. Forty-eight people were killed including the Air Minister, Lord Thomson, and the *R101*'s captain, thirty-six-year-old Herbert Carmichael Irwin. Following the loss of the dirigible, the *R100* was immediately grounded and the British airship programme effectively came to an end.

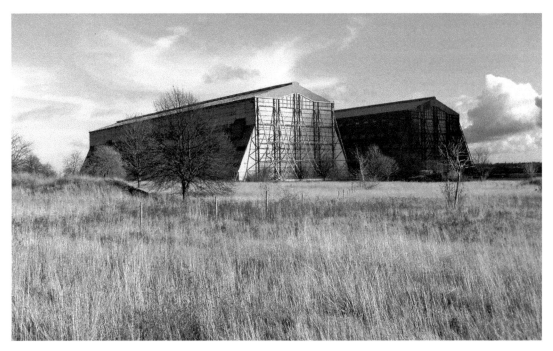

The colossal airship sheds at Cardington on the outskirts of Bedford. (Matthias Pfeifer)

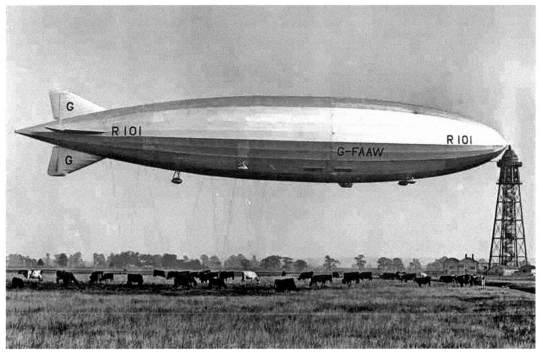

The giant airship *R101* photographed at its mooring mast at Cardington. On 5 October 1930 it crashed in France with the loss of forty-eight lives.

The twenty-year period between the two world wars was very much a 'golden era' for the investigation of mediums and their claims to be able to communicate with the departed. One of the most high-profile researchers was Harry Price (1881–1948), who ran his own National Laboratory of Psychical Research from a large town house in Queensberry Place, South Kensington. Today, Price's most well-known case is that of Borley Rectory, the so-called 'most haunted house in England', which burnt down in mysterious circumstances in 1939. However, much of Price's work involved the investigation of spiritualist mediums in his purpose-made séance room, and it was here on Tuesday 7 October 1930 that the psychical researcher had a remarkable experience.

Three months before, on 7 July, Sir Arthur Conan Doyle, the creator of Sherlock Holmes and an ardent champion of spiritualism, had died. Price and Conan Doyle had crossed swords on a number of occasions over the reality of survival after death, and at the request of journalist Ian Coster, Price agreed to hold a séance with the respected trance medium Eileen Garrett to discover if the famous writer could communicate. At three o'clock in the afternoon, a daylight séance took place at Price's laboratory with Mrs Garrett, Price and Coster, together with Price's secretary, Miss Beenham, who took a shorthand record of the entire sitting.

Almost at once, the medium was overshadowed by a personality who claimed to be the dead captain of the downed *R101* airship. 'Irwin' claimed there were numerous technical problems with the airship and maintained that political pressure involving the Air Ministry and the rival *R100* had forced the flight to go ahead despite the craft being unsafe. Price compiled a detailed list of the ghostly 'Irwin's' technical comments, which ran to several pages. These were later examined (in a private capacity) by a member of the *R101* crew at Bedford who felt much of the transcript could not have been transmitted to Mrs Garrett by normal means.

Ghost hunter extraordinaire Harry Price (1881–1948), who took part in the *R101* séance in 1930. (Author's collection)

Medium Eileen Garrett (1893–1970), who seemingly contacted the dead captain of the *R101* airship during a séance in London. (Author's collection)

The *R101* séance remains controversial. Sceptics claim (without actually providing any solid evidence) that Mrs Garrett knew much about the airship disaster beforehand and that the sitting was fraudulent. In 1979, American writer John Fuller published *The Airmen Who Would Not Die*, which championed the case, while other writers, including the usually sceptical commentator Archie Jarman, came to a similar conclusion.

DID YOU KNOW ... ?

Matthew Hopkins, immortalised by actor Vincent Price in the 1968 historical horror film *Witchfinder General*, came to Bedford during the time of the English Civil War. Hopkins is the most notorious of the seventeenth-century witch finders and is thought to have been responsible for the deaths of around 300 people during a period of three years beginning in 1644. Before Hopkins came to Bedfordshire, witchcraft fever had already manifested itself. On 31 March 1612, Mother Sutton from Milton Ernest was hanged after being imprisoned in Bedford Gaol, which at the time was located on the corner of present-day Cauldwell Street and St John's Street. Mother Sutton, a pig keeper, was said to have bewitched a neighbour's horses and caused his servant to fall into a trance after stroking him with a beetle. In the spring of 1666, four women from Dunstable were tried at the Bedford Assizes, accused of 'bewitching small children to death', but were acquitted. It was said that one of the accused, Elizabeth Pratt, had been visited by the Devil in the form of a cat.

In a document made at Newnham Priory in 1506 there is reference to a 'Cucking-Stool Lane' in Bedford – the cucking or ducking stool was a punishment device used to douse unruly women or 'scolds' in rivers and ponds, and also as a means of identifying witches. Records also show that as late as 1735, a woman from Oakley was both tied and 'swum' from the old Mill Bridge. After floating instead of sinking (a bad sign – if she had drowned she would have been innocent!) she was then weighed against the church Bible for her alleged witch crimes. Thankfully on this occasion her innocence was proved by the fact that she weighed more than the Holy Book and she was released. Compensation, it would seem, was not an option in what were both superstitions and dangerous times.

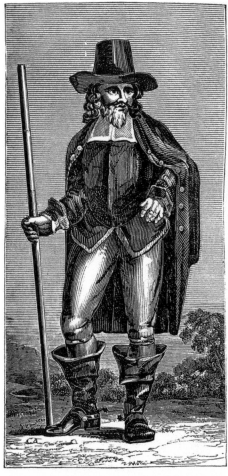

**MATTHEW HOPKINS,**
OF MANNINGTREE, ESSEX,
THE CELEBRATED WITCH-FINDER.

Matthew Hopkins (c. 1620–47), the self-styled 'Witchfinder General' who came to Bedford during the witch purges of the seventeenth century.

# 5. Murderous Bedford

The centuries-old Assize method of criminal justice began in the 1100s and lasted up until 1971 when it was replaced by the current Crown Court system. England was covered by six Assizes with Bedfordshire being assigned to the Norfolk Circuit. Throughout the eighteenth century up until the beginning of the 1800s, executions took place at Gallows Corner, a spot located on Bromham Road on the bend near the junction with the present-day Beverley Crescent.

During the 1700s, 204 death sentences were passed by the town Assize court, of which there were forty-two confirmed executions, and a study of the records suggests that just over a dozen more may well have taken place. Highway robbery was by far the most common crime leading to the death penalty, but you could also be hanged for animal theft (sheep and horses being the favourites) as well as for burglary and robbery from a dwelling.

Four of those executed during this period were women. On 2 August 1735, Ann Virgin was hanged for the murder of her illegitimate child. The child's father, Ann's late sister's husband, was found to be complicit in the killing and was executed with her. Another murderess, Sarah Addington, went to the gallows on 3 August 1767 for the killing of a neighbour, Mary Dunton. Criminal acts against property, what become known in later years as the 'Bloody Code', was also a capital offence. On 1 April 1780, Mary Shelton went to Gallows Corner for housebreaking, while three years later, on 23 August, Sarah Cave suffered the same fate for arson.

On occasions the bodies of executed felons were publicly gibbeted as a warning to others and as a mark of the severity of their crimes. The bodies of two Gallows Corner executions are known to have suffered this fate. After his execution on 28 July 1744, the body of John Knott, found guilty of the murder of Henry Roberts, was hung in chains on Luton Down, most likely on a gallows near Galley Hill. Similarly, Gabriel Tomkins, who robbed the Chester Mail coach, was gibbeted on what is now the present-day A5 between Dunstable and Hockliffe following his execution on 23 March 1750. Tomkins was a former bricklayer from Tunbridge Wells who later became the leader of the Mayfield smuggling gang on the south coast.

All of the criminals mentioned would have been incarcerated in the county gaol prior to their execution. During the 1700s, this was located on the corner of the High Street and Silver Street. There were day rooms for debtors and felons, as well as two cells for the condemned and two dungeons. This was the building visited by prison reformer John Howard during the time that he was High Sheriff of Bedfordshire, and where John Bunyan was held in the mid-1600s.

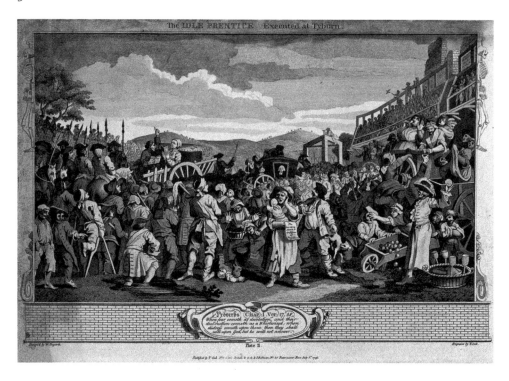

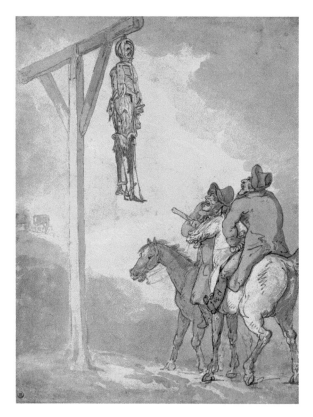

*Above*: An engraving by Hogarth of a typical hanging at Tyburn in London. Similar crowds flocked to see public executions at the Bromham gallows in Bedford.

*Left*: *The Gibbet* by caricaturist Thomas Rowlandson (1756–1827), a slightly humorous look at the macabre spectacle familiar to eighteenth-century Bedfordians.

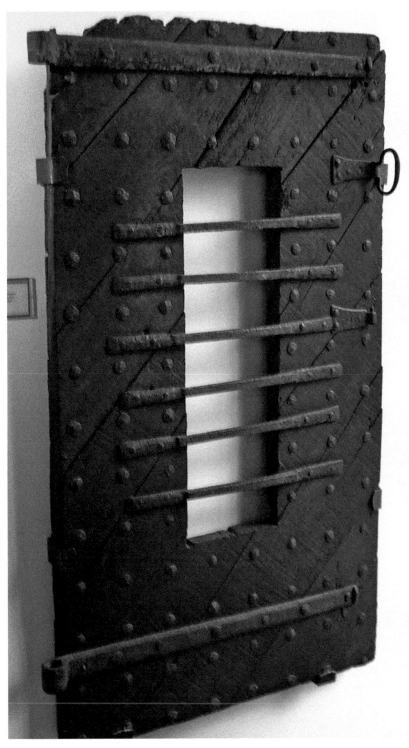

An original cell door from the old county gaol on the corner of Silver Street and the High Street, now in the collection of the John Bunyan Museum. (Simon Speed, with kind permission of the John Bunyan Museum)

The 1800s saw a total of nineteen executions taking place at Bedford. When James Hughes was hanged in March 1800 it was the last time that an execution was to take place at Gallows Corner. By this time construction of a new county gaol was well underway and it opened officially on its present site on 18 June 1801. After this time all hangings took place at Bedford Gaol, although they were still a public spectacle. The first time the new gallows was used was less than two months after the prison's opening, when on 1 August there was a double event. John Brown mounted the scaffold first to pay for his crime of housebreaking. He was followed a short time afterwards by William Pepper, who paid the ultimate price for stealing a flock of sheep.

In 1823, the passing of the Judgement of Death Act made executions under the 'Bloody Code' discretionary for acts of housebreaking and theft. This was not enough to save James Walker, who was hanged on 31 March 1827 for horse theft; John Lincoln, who went to the scaffold for burglary the following year; and James Addington, who was executed for arson on 24 March 1832. Attempted murder was also a capital offence, as demonstrated in the case of Lilley brothers Matthew and William from Kempston in a double execution on 4 April 1829. The previous month they had been challenged during a night-time poaching excursion by gamekeeper Thomas King. When Matthew Lilley, aged twenty-eight, fired on and wounded King, he sealed not only his own fate but that of his teenage brother as, despite a recommendation for clemency from the prosecution and a petition from the people of Bedford, they went to their deaths together.

DID YOU KNOW ... ?

The last public executions in Bedford took place in 1843 and 1868. Sarah Dazley is known in the criminal pantheon as the 'Potten Poisoner'. On 22 July 1843, she stood trial for the murder of her second husband who had died in suspicious circumstances. The Marsh Test, an early forensic procedure, had established that William Dazley's body was full of arsenic and it was known that Sarah had been attempting to 'cure' an ongoing illness by giving him homemade pills. She was also suspected of poisoning her first husband, Simeon Mead, and their infant son. Such was the spectacle of the first public execution of a woman in the county (and last as it turned out) that an estimated 7,000–12,000-strong crowd watched as Sarah Dazley went to the scaffold on 5 August 1843. A similarly large crowd gathered on 31 March 1868 when forty-five-year-old poacher William Worsley was hanged for his part in the murder of a man in Luton. Worsley went to his death just over three months before the last ever public hanging took place at Newgate the same year. On all these occasions the hangman was William Calcraft, the longest-serving British executioner who officiated at around 450 hangings over a period of forty-five years. Calcraft was renowned for using the shortest of drops when dispatching the condemned, with the result that instead of a clean and instantaneous death, many felons were in fact strangled to death.

The nineteenth-century hangman William Calcraft (1800–79), who carried out several executions at Bedford Gaol.

Another double tragedy, an event which has become known as the 'Tennis Lawn Murder', took place in Bedford in 1883. On the evening of 17 July, a small party was playing tennis on a court at the rear of The Ship public house in St Cuthbert's Street. Among them was Miss Kempson, the daughter of the rector of St Cuthbert's Church, and her friend Miss Eleanor McKay. At a recent dance, young Eleanor had rejected the affections of twenty-two-year-old Lieutenant Hubert Vere, who had recently returned from Egypt where he had served with the 2nd Battalion of the York & Lancashire Regiment in the campaign at Tel-el-Kebir. Whether Vere was suffering from some form of post-traumatic stress following his experiences in Egypt is unclear, but his continued obsession with Eleanor McKay was to have deadly consequences. On the evening in question, Vere made his way to The Ship and approaching the tennis party drew out his revolver. He shot Miss Mckay at point-blank range through the chest and immediately turned the gun on himself. A letter to his mother and a photograph of his victim were found in his coat pocket.

During the course of the twentieth century, a total of 1,485 death sentences (1,340 men and 145 women) were passed in the United Kingdom. Of these, 740 men and thirteen women kept an appointment with the hangman. Those found guilty of capital crimes

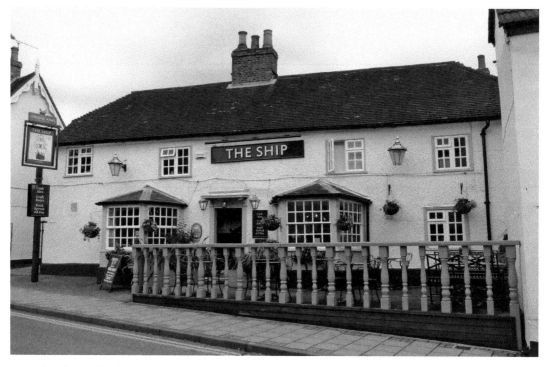

The Ship public house in St Cuthbert's Street, where Hubert Vere shot Eleanor Mckay on 17 July 1883. (Paul Adams)

committed in the northern Home Counties, including Northamptonshire and the old administrative county of Huntingdonshire, spent their last days in the condemned cell at Bedford Gaol, where the gallows were operated on seven separate occasions between 1902 and 1962. All those executed were male and three shared William as their Christian name.

On the evening of 23 September 1902, Police Constable Whinnett, on duty in the quiet village of Eversholt near Woburn in Bedfordshire, attended an incident at a pair of isolated cottages situated in a narrow lane opposite Waterend Farm. In one he found the bodies of Mary Oakley, a widow in her early seventies, together with her married daughter, Emily Chambers, aged thirty-five. Both had been killed with a shotgun fired at close range. The neighbouring cottage belonged to Martha Pepper and it was she who had raised the alarm.

Soon after, PC Whinnett was called to the nearby Falcon Inn at Lower Rads End where the landlord, Joseph Brinklow, had detained an injured man in one of the back rooms. This proved to be William Chambers, a forty-seven-year-old telephone engineer from Flitwick, with a self-inflicted gunshot wound to the face. A shotgun covered with blood was later found discarded in some allotments behind Mary Oakley's cottage.

William Chambers appeared at the County Assizes at the Shire Hall in Bedford on 13 November 1902 charged with the murder of his wife and mother-in-law. He and Mary Chambers had been married for ten years but there had been much violence and unhappiness and early in September Mary had walked out and gone to stay with

# WIFE AND MOTHER-IN-LAW MURDERED.

A terrible tragedy took place at Eversholt, a village near Woburn Park, Bedfordshire.

William Chambers, a telephone employee, from London, had been living at Flitwick, near Ampthill, for about six months. He and his wife separated some years ago, but had come together again; but, in consequence of her husband's threats, Mrs Chambers recently went to stay with her mother, who lived at Eversholt.

The mother and daughter were sitting talking to Mrs Hazell, another daughter of Mrs Oakley, when Chambers suddenly entered by the back door, with a double-barrelled gun, and, it is alleged, without a word, shot his mother-in-law through the neck, and then fired at his wife, the bullet entering the lower part of the face. Both women expired almost immediately. The other woman rushed out of the room and closed the door, holding it as long as she could, and then ran from the house and raised an alarm.

Chambers also left the house and went across an allotment field, where he shot himself through the jaw and dropped his gun. He then managed to stagger into the Falcon public-house, where he could only gasp, "Brandy, brandy." The landlord, however, refused to serve him, and having heard something of the occurrence he enticed Chambers into a back room, and kept him there until the police arrived. Chambers was taken to the Woburn police station, and later to the cottage hospital, where it was found that part of his jaw had been blown away.

At the inquest, it transpired that the wife had been to see a Woburn solicitor with reference to getting a separation order, and the supposition is that Chambers heard of this, with the result that he paid the visit to his mother-in-law's house.

The jury returned a verdict of "Wilful murder" against Chambers.

Contemporary newspaper account of the murder of Mrs Oakley and her daughter by William Chambers. (Author's collection)

her mother at Eversholt. Chambers had been hopeful of a reconciliation, but when he received notice that his wife intended to apply for a separation order and was also seeking maintenance from him, events quickly turned to tragedy.

Around four o'clock on the afternoon of 23 September, Chambers was seen leaving Flitwick carrying a parcel under his arm. Three hours later he burst into the kitchen of the cottage at Water End and first shot Mrs Oakley and then her daughter who were both sitting beside the fire. The attack was witnessed by Mrs Hazell, Mary Chamber's married sister, who managed to escape when Chambers paused to reload his weapon. Fleeing from the house, the murderer attempted to turn the gun on himself but was unsuccessful and soon after staggered into the nearby pub where he was eventually arrested. Despite a plea of insanity, on the second day of the trial the jury took only five minutes to find William Chambers guilty and he was hanged by William Billington and Thomas Scott at Bedford Gaol at eight o'clock on the frosty morning of 4 December 1902. Despite the cold weather, a large crowd gathered around Adelaide Square to hear the tolling of the prison bell and see the notices of execution posted on the main gate. After a brief inquest, his body was buried in a deep grave in the rear of the prison.

Thirteen years later another William, this time forty-two-year-old unemployed drunkard William Reeve, went on trial at the Bedford Assizes for a crime that shared several similarities with the events at Eversholt. Reeve was accused of shooting his

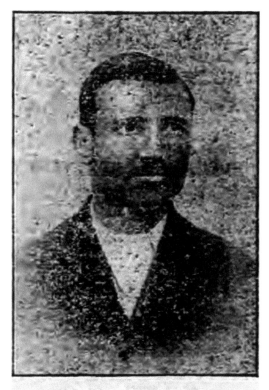

WILLIAM CHAMBERS.

Murderer William Chambers, who went to the gallows at Bedford on 4 December 1902. (Author's collection)

wife to death and had also attempted suicide immediately afterwards, in this case with a shaving razor. On the evening of 5 July 1915 he had been found staggering along Plantation Street in Leighton Buzzard by Police Constable Clark, who, a short time later, discovered the body of Harriett Reeve dead in an armchair in their house at No 8. Prompt first aid administered by PC Clark saved Reeve's life, but it was only a temporary reprieve. The Bedford jury, on 19 October, were ultimately unconvinced that a shotgun in his possession had fired by accident as it was unloaded, preferring to believe (after retiring for less than a quarter of an hour) that Harriett's death was a deliberate act following a prolonged bout of heavy drinking on her husband's part. William Reeve was dispatched on the Bedford gallows on 16 November 1915 by Rochdale hangman John Ellis, who five years before had executed the notorious London cellar murderer Dr Crippen.

Another English murder case and one that continues to make headlines nearly ninety years after the event is that of Alfred Rouse and the 'Blazing Car Murder'. In the early hours of the morning of 6 November 1930, two men walking along a lonely lane near Hardingstone on the outskirts of Northampton saw a fire in the distance that they initially assumed was a Guy Fawkes bonfire. As they approached what proved to be a burning Morris Minor car, they passed a smartly dressed man coming in the opposite

Alfred Arthur Rouse, hanged at Bedford Prison on 10 March 1931 for the 'Blazing Car Murder'.

direction and got a good look at his face. After the fire had been extinguished, a series of gruesome facts came to light. In the smouldering wreckage was the badly burnt body of a man and what little remained of his clothing was soaked with petrol. A wooden mallet discarded on the grass verge nearby when examined was found to have recently struck a human head.

A vital clue for Northamptonshire Police was the car's number plate – MU1468 – which was retrieved intact. This led them the following day to Alfred Arthur Rouse, a philandering commercial traveller in his late thirties who was picked up in London. After initially fleeing to Wales, Rouse saw newspaper headlines about the discovery of his Morris Minor and decided the best course of action was to turn himself in and attempt to bluff his way out of trouble. He claimed he had offered a lift to a man while driving to Leicester and, becoming low on fuel, had stopped beside the road near Hardingstone. Asking his passenger to top up the tank with a jerry can of petrol, he went to relieve himself in some nearby bushes. The fire had been an accident – the passenger had been smoking a cigar as he attempted to refuel the car – and Rouse, unable to rescue the man from the flames, had panicked and fled the scene.

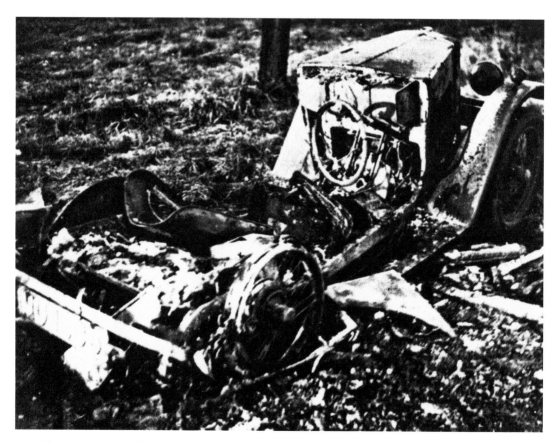

The Rouse case. The burnt-out Morris Minor in Hardingstone Lane. (Author's collection)

Rouse's week-long trial began at the Northampton Assizes on 26 January 1931. Forensic evidence presented by the noted pathologist Sir Bernard Spilsbury cast serious doubt on his story, the prosecution suggesting that Rouse had committed murder in an attempt to fake his own death to avoid numerous debts, paternity payments and charges of bigamy. Far from being in a panic, Alfred Brown and William Bailey testified that Rouse was calm and collected as he passed them in the lane on the night of the murder. Found guilty, Rouse was hanged by Thomas Pierrepoint and Thomas Philips at Bedford on 10 March 1931. In a letter written to and subsequently published by the *Daily Sketch* on the day following his execution he confessed to the crime.

A notable feature of the 'Blazing Car Murder' is the mystery surrounding Alfred Rouse's victim, whose identity remains unknown. In his confession, Rouse claimed he had picked the man up at the Swan and Pyramid pub in Whetstone High Street and had not asked his name. Despite recent DNA analysis carried out on archived crime scene evidence in 2014 and 2015 by Leicester University, a match with several people known to have gone missing around the time of the murder in 1930 has not been possible. The man from the Morris Minor is buried with a simple marker in St Edmund's churchyard in Hardingstone, while the nearby scene of the murder has been transformed by new roads and housing development.

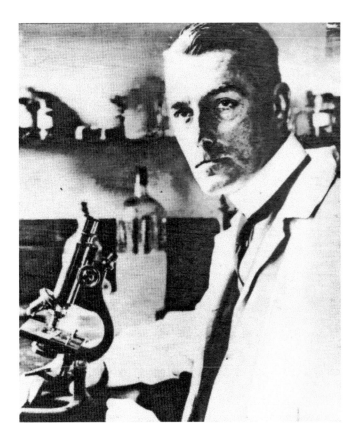

The pathologist Sir Bernard Spilsbury (1877–1947), who gave evidence for the prosecution in the Rouse case.

Thomas Pierrepoint, accompanied by his now better-known nephew Albert, returned to Bedford Gaol on 9 July 1935. Pierrepoint senior's return and the location of the gallows in a wooden shed in a remote part of the prison brought rise to the nickname of 'Uncle Tom's cabin'. There the following morning they executed poultry farmer Walter Worthington, another wife murderer who like Chambers and Reeve killed his spouse, twenty-eight-year-old Sybil Worthington, with a shotgun. The tragedy took place at Broughton near Huntingdon. Worthington, nearly thirty years older than Sybil and with three sons from a previous marriage, had become convinced that she was having an affair with a young nephew who lived with his parents at the nearby Crown Inn. Lionel Wright denied there was anything between himself and Mrs Worthington, but the jealous farmer was unconvinced and on 9 March 1935 he killed her with a single shot in front of his

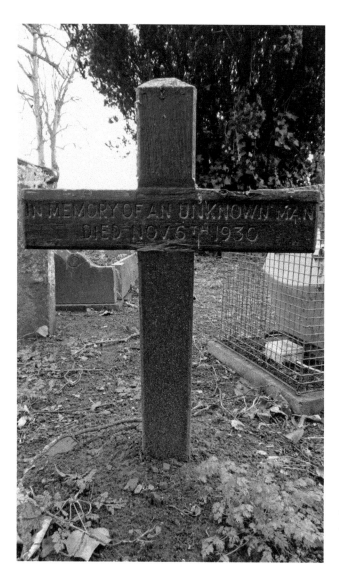

The grave of the unknown victim in the Rouse case in St Edmund's churchyard, Hardingstone. (Paul Adams)

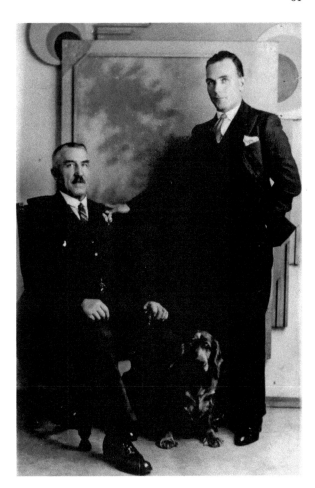

Thomas Pierrepoint (left)
with his nephew Albert, the
Yorkshire hangmen who carried
out two executions, together at
Bedford Prison.

family. The Pierrepoints were to return to Bedford for the final time five years later when twenty-four-year-old William Cooper, a disgruntled workman, killed his former employer in a bungled wartime robbery. Cooper had battered John Harrison to death in an isolated hut at Thorney on the outskirts of Peterborough. Sentenced at Cambridge Assizes, he spent his last days in the condemned cell at Bedford Gaol and walked to the gallows on 26 November 1940.

DID YOU KNOW ... ?
The last two hangings at Bedford Gaol were carried out by the Yorkshire hangman Harry Allen. A bus driver and later a publican, Allen always wore a black bow tie on the day of an execution as a sign of respect. He was familiar with Bedford, having taken part at the execution of William Cooper as an observer in 1940 during his training.

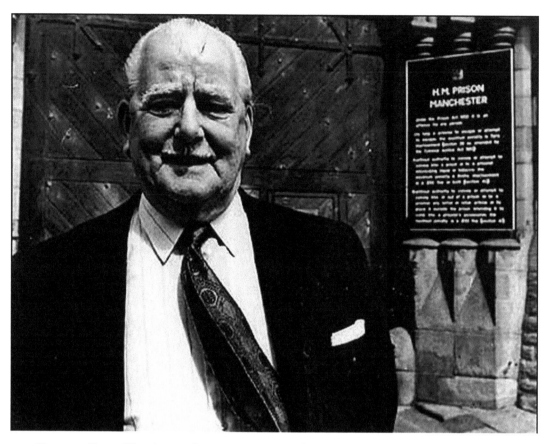

Hangman Harry Allen (1911–92) in retirement outside Strangeways Prison in Manchester. He officiated at the last executions at Bedford in the early 1960s. (Wandsworth Prison Museum)

The final executions at Bedford took place appropriately enough during the last years of capital punishment in Britain. Jack Day, a car salesman and former dirt-track rider in his early thirties, was the fifteenth to last person to be hanged in this country. Married with a young child, he and his wife Margaret lived in a small terraced house in Edward Street, Dunstable. During the afternoon of 23 August 1960, he had been testing the stamina of fellow drinkers in the Horse & Jockey pub in Kensworth with a display of Russian roulette using a pistol loaded with live ammunition. Returning home, Day discovered his wife talking with a local factory worker, twenty-five-year-old Keith Arthur, who had called on the house to ask her husband if he wanted to go for a drink. Convinced that the two were having an affair, Day took out his pistol and shot Arthur in the neck. The body was taken to an isolated outbuilding at Isle of Wight Farm on the nearby Dunstable Downs, but the shooting had been witnessed by a young babysitter, Patricia Dowling, and the car dealer was arrested. Day claimed he had only meant to frighten his victim and that the weapon had gone off accidentally. The jury was unconvinced and despite an appeal and a subsequent delay due to a legal wrangle with *The Spectator* magazine, Jack Day, whose fascination with firearms ultimately led to his death, was executed at 8.00 a.m. on 29 March 1961.

The house in Edward Street, Dunstable, where Jack Day shot Keith Arthur on 23 August 1960. (Paul Adams)

A year later, the lever on the gallows at Bedford Gaol was pulled for the very last time. This proved to be a controversial execution as for many years it was felt by some that James Hanratty, the notorious 'A6 Murderer', had been the victim of a miscarriage of justice. A petty criminal, Hanratty had picked up Michael Gregsten and Valerie Storie on the evening of 22 August 1961 after accosting the couple in their car in a field at Dorney Reach in Buckinghamshire. Held at gunpoint, Gregsten, a government scientist from the Transport Research Laboratory, was forced to drive aimlessly around North London until in the early hours of the following morning the trio reached Luton and headed north on the A6 towards Bedford. At Clophill, Gregsten was forced to pull over into a lay-by at the ominously titled Deadman's Hill, which proved to be a prophetic location. After killing Gregsten, Hanratty raped and shot Valerie Storie, leaving her for dead before fleeing in the car back to London. Storie survived the assault but was paralysed for life. Hanratty was arrested in Liverpool and stood trial at the Bedford Assizes on 22 January 1962. Found guilty after a lengthy trial, he spent his last days only a few hundred yards from the A6 road that has become synonymous with his name, and went to his death on 4 April 1962. Following Hanratty's trial and execution, capital punishment abolitionists including journalist Paul Foot championed the case as a miscarriage of justice, but in 2002 DNA evidence proved conclusively that the London-born criminal was the real A6 killer.

The 'A6 Murderer' James Hanratty, the last person to walk to the gallows in Bedford Prison on 4 April 1962. (Author's collection)

# 6. Religious Bedford

The most familiar religious association with Bedford is that of the seventeenth-century Puritan preacher John Bunyan, author of the Christian allegory *The Pilgrim's Progress*, published in 1678 and cited as being the first novel written in English. Bunyan, a tinker by trade who was born in the village of Elstow in 1628, was famously incarcerated in Bedford Gaol for twelve years due to his nonconformist views on the established Christian church. Following his release, he continued to write and preach, eventually falling ill during a journey to London where he died on 31 August 1688. Although his story is an important one, perhaps the most remarkable and interesting of Bedford's religious figures was not to appear until over 200 years after John Bunyan's death.

Up until very recent times, the world of the Panacea Society and its members, the Panaceans of Bedford, was perhaps the town's most closely guarded secret. With the opening of the Panacea Museum in Newnham Road, light has now been shed on what

A nineteenth-century portrait of the preacher and author John Bunyan (1628–88), one of Bedford's most familiar historical figures.

for nearly a century has remained a modern enigma, although as with all good tales such as this, some of the mystery still remains. The Panacea story begins in the immediate aftermath of the First World War, although it has close links with events that took place in England over a hundred years before.

In 1919, Mabel Barltrop, a vicar's widow living in Albany Road in Bedford, became inspired by the life and writings of Joanna Southcott (1750–1814), an Englishwoman and religious mystic from Taleford in Devon. A startling revelation had overtaken Joanna, who worked as a domestic servant in Exeter, when she was fifty years old. She began taking down automatic writing (similar to the Revd Stainton Moses who we have already encountered) and came to believe that she was the Biblical 'Woman clothed in the Sun' or 'Woman of the Apocalypse' described in the Book of Revelation. Her trance scripts became voluminous and were eventually published in sixty-five separate books. However, some writings were held back and known only to Joanna. These prophecies were collected together and sealed inside a locked trunk, which became known as 'Joanna Southcott's box', only to be opened during a time of growing crisis when her words would bring about the salvation of Mankind.

The eighteenth-century prophetess and author Joanna Southcott (1750–1814), whose mysterious life was the inspiration for Bedford's Panacea movement.

In 1814, Joanna (aged sixty-four and a virgin) announced that an immaculate conception had taken place and that she was going to give birth to Shiloh, the New Messiah as described in the Book of Genesis. Several doctors including the royal physician examined Joanna and confirmed that she was indeed pregnant. Preparations were made for the event, and in order that the child would not be born illegitimate, in the ninth month of her 'pregnancy' a marriage ceremony took place with one of her followers. Despite going into labour on Christmas Day 1814, no physical birth took place and as the day wore on, Joanna's supporters were forced to the conclusion that Shiloh was in fact an etheric child who had no material form. Soon after the 'birth', Joanna began to fade and she died the following day. Even when it became clear that Joanna would not be raised from the dead, her movement continued for some years and her box of prophecies became a relic handed down and kept ready for the time when it would be needed in the future.

In Bedford a century later, the story of the etheric child Shiloh came to have great meaning to the widowed Mabel Barltrop. She came to believe that she was the reincarnation of Shiloh and as such was a new prophet for the modern age. She named herself 'Octavia' and gathered around her twelve female apostles, an assortment of widows, spinsters and suffragettes, who became the nucleus of the Panacea Society. The Panaceans were moved to buy several homes in Albany Road and the Embankment area – as according to 'Octavia', Bedford was the site of the original Garden of Eden – where at its very centre a small chapel was built. The society eventually owned a total of twenty-six properties, one of which, a corner house at No. 18 Albany Road, was named 'The Ark' and kept in readiness for the physical presence of Christ, who would move there following his return to Earth.

Like Joanna Southcott, 'Octavia' took regular dictation from God in the form of automatic writing, in her case at 5.30 p.m. every day for five years. The result ran to sixteen volumes entitled *The Writings of the Holy Ghost*. The Panaceans believed that they were the chosen few and Octavia never strayed more than seventy-seven paces from her home, believing that beyond this distance she would be immediately devoured by Satan.

The notion of a protective ark was further expanded in 1925 when members of the society buried several squares of linen prepared by 'Octavia' in the countryside around Bedford in a vast ring 12 miles in diameter with its centre on the Panacean chapel. This was to create a safe haven in the event of the national crisis that the Panaceans felt was imminent and for which they vigorously lobbied the Church of England to assist in the opening of Joanna Southcott's box and the final revelation of her secret prophecies. The box could only be opened in the presence of twenty-four bishops (representing the elders of the nation) for whom the Panaceans had prepared one of their houses in Newnham Road (the present-day Panacea Museum), complete with bedrooms, for the bishops to stay and a room in which the opening would take place. A national publicity campaign involving billboard posters on buildings and buses took place during the interwar years but met with no success.

DID YOU KNOW ... ?

Harry Price, the flamboyant ghost hunter who we have already met, opened what he claimed to be Joanna Southcott's box in 1927. This box was donated anonymously to Price's National Laboratory of Psychical Research on 28 April 1927. Price had several mediums, including Eileen Garrett from the R101 séance and Francis Naish (who claimed by means of a dowsing pendulum he had contacted the spirit of Joanna), to examine the box psychically, after which it was X-rayed. Price dutifully wrote to twenty-four bishops informing them of his intention to open the box, but in the end only Dr Hine, the Bishop of Grantham, decided to take part. Amid much publicity, which was grist to the mill as far as Harry Price was concerned, Joanna Southcott's box was opened in public at the Hoare Memorial Hall, Westminster, on 11 July 1927 at 8.00 p.m. The box's contents when revealed proved to be a damp squib where the prophecies of Joanna Southcott were concerned. Harry Price's box contained an assortment of eighteenth-century junk including a horse pistol, a lottery ticket, earrings, a purse and a nightcap. The Panaceans claimed to have the 'real' Southcott box, the provenance of which they could trace back to Joanna's death in 1814. This was passed to them by the last owner, Cecil Jowett, on 27 May 1957 and today is said to reside in a bank vault in London.

Harry Price X-raying 'Joanna Southcott's box'. It was opened in a flood of publicity but with only one bishop on 11 July 1927.

# THE PANACEA SOCIETY

# NOTICE

TO

# SEALED MEMBERS

AND

# WATER TAKERS

Should a State of Emergency arise whereby communication with Head Quarters is interrupted or becomes difficult, continue to fill your bottle with Water as required and repeat the Blessing.

Sprinkle your Houses.

## THE PANACEA SOCIETY
### BEDFORD

A handbill produced for members of the Panacea Society following the outbreak of hostilities in 1939.

Since the early 1920s, the Panacea Society offered (for no charge) a global healing service which came directly from 'Octavia' herself. In 1921 she eschewed ordinary medication for ailments and only used tap water that she blessed herself. Rolls of linen were breathed on by 'Octavia' and then cut up into small stamp-sized pieces and placed in jugs of drinking water. Over the years, applications for the healing water came from over 120,000 people across the world.

Despite her own belief and that of her followers that she was the etheric Shiloh reborn on Earth, 'Octavia' died on 16 October 1934. She is buried in the Foster Hill Road Cemetery, her grave marked with a simple stone bearing the initials 'M. B.'. According to Panacean belief, Octavia and the rest of her followers wait in spirit form on the planet Uranus for the time when they will again return to earth in human form.

DID YOU KNOW ... ?
A *panacea*, after which the Panacea Society is named, is a long-sought after universal remedy for health, well-being and everlasting life, which is named after the Greek goddess Panacea. She is one of the names intoned in the Hippocratic oath taken by doctors and physicians at the beginning of their careers in medicine.

By 2003, the Panacea Society had dwindled to just a handful of members, of which architect John Coghill, a Panacean since 1934, and Ruth Klein, who applied for the healing water for the first time in 1972, were the last. The first real glimpse inside the world of the Panaceans came with Russ Clapham's documentary *Maidens of the Lost Ark*, which aired on Channel 4 that year. With the death of Ruth in 2012, the Panacea Society ceased to exist, closing one of the most unique chapters of Bedford's history. Today the Panacea Charitable Trust, which represents and administers the old society's considerable assets, operates a museum dedicated to preserving its remarkable history as well as acting as a beneficiary to charitable causes in the area.

# 7. Cinematic Bedford

Bedford may not immediately spring to mind where film locations are concerned, but its place in the modern British film industry is well represented. The unique environment of the Cardington airship sheds have been a major factor in putting the town on the cinematic map in recent years, although the town itself and surrounding areas have also been utilised both on the big and small screens.

The film that gives Bedford a large amount of nostalgic screen time is *Personal Affair*, directed by Anthony Pelissier and released in October 1953 by Two Cities Films. Written by Mabel Cowie, the story of a teenage student's crush on a married college teacher and its potentially dangerous ramifications showcases several locations around the town centre, each one a miniature vignette of 1950s life. These include the bridge over the Great Ouse, the Swan Hotel, the Embankment, and several shopping streets including the High

Poster for the 1953 drama *Personal Affair* filmed at several locations around Bedford town centre. (Author's collection)

Street and Castle Lane. Leo Genn played Latin teacher Stephen Barlow, who is accused of murder when young Barbara Vining (Glynis Johns) goes missing, while the supporting cast included a steady rank of British character actors including Megs Jenkins, Thora Hird and (later Sir) Michael Hordern.

In 1965, director Ken Annakin assembled an all-star cast for his ambitious comedy epic *Those Magnificent Men in Their Flying Machines*. Among the actors taking to the air on an international air race from London to Paris were Stuart Whitman, Terry-Thomas, Eric Sykes, Dame Flora Robson, Benny Hill and Tony Hancock, and production saw many locations being used across the south of England. One site that provides a cinematic link to Bedford is the Old Warden railway tunnel on the former branch line that ran from the town to Hitchin. Like many provincial lines, by the mid-1960s its days were numbered and, already closed to passenger traffic, the Bedford–Hitchin line closed in 1964. It was then the ideal spot for a daring stunt set up by Ken Annakin and his crew whereby a biplane, ostensibly piloted by Terry-Thomas, lands on the carriage roof of a passing steam locomotive and is smashed to matchwood against the Old Warden Bridge.

The year 1971 saw the return of more aircraft to Bedford, this time of a variety with an intimate connection with the area. When it became necessary for director Etienne Périer to recreate two vast airship hangars for his First World War action drama *Zeppelin*, the Cardington hangars were the obvious choice. Although the hangars themselves were real, carefully built and painstakingly exact scale models stood in for the airship itself, around which writer and producer Owen Crump built his story of a daring wartime plot to steal the Magna Carta from a remote Scottish castle. Michael York, Elke Sommer and veteran actor Anton Diffring were the stars.

A replica 1911 Avro Triplane '12', built for the film *Those Magnificent Men in Their Flying Machines* and now a permanent exhibit in the Shuttleworth Collection, Old Warden. (Alan Wilson)

Poster for the 1971 action film *Zeppelin*. Scenes were filmed at Cardington by director Etienne Périer. (Author's collection)

The same year that airships returned to the town, the streets of Bedford were used for a completely different slice of cinema action, in this case Michael Tuchner's violent crime thriller *Villain* starring Richard Burton as the Ronnie Kray-inspired London gangster Vic Dakin. Although mostly filmed on location in London, the crew filmed a 'blink and you'll miss it' scene in the middle of Bedford where a police Rover escorting an ambulance can be seen passing along the High Street and crossing the Silver Street/Mill Street junction.

One particular success story to emerge from the post-war British film industry was Hammer Films who, for a period of over twenty years beginning in the mid-1950s, shocked and thrilled cinemagoers with their distinctive brand of home-grown horror. Where locations were concerned, Hammer's most frequently visited site was the distinctive Black Park in Wexham, Buckinghamshire, close to Pinewood Studios.

Hammer Film's 1974 *Captain Kronos: Vampire Hunter*. Location work was shot at Ampthill Park and Houghton House on the outskirts of Bedford. (Author's collection)

However, they did head to Bedfordshire on one occasion for the quirky 1974 cult favourite *Captain Kronos – Vampire Hunter*, which starred German actor Horst Janson as the titular hero, assisted by hunchback assistant Hieronymous Grost, played by John Cater. Houghton House, the ruined seventeenth-century hunting lodge at Houghton Conquest, stood in for Durward Hall, home of the sinister vampire Lord Hagen and his blood-drinking family, while the rolling stretches of Ampthill Park can be seen in the opening and closing title sequences. The director of this particular slice of Hammer Horror was television writer Brian Clemens, best known for iconic series such as *The Avengers* and *The Professionals*. Houghton House was dismantled at the end of the eighteenth century, leaving the ruins that are now in the care of English Heritage. Its grand staircase was taken out and built into the Swan Hotel on the Embankment in Bedford where it can be seen today.

DID YOU KNOW ... ?
Bedford has been the subject of a major alien invasion – at least where the world of science-fiction is concerned. In 1964, television scriptwriter Terry Nation set to work to bring his iconic space villains, the Daleks, back to the small screen. The iconic creatures had been an immense success when they had effectively launched the ever popular *Doctor Who* series in a four-part adventure at the end of the previous year. As the title of his new serial made clear, Nation's 'The Dalek Invasion of Earth' brought the mutant robots uncomfortably close, particularly for the residents of Bedford as the town was transformed into a vast open-cast mine as part of the Daleks' plan to steal the planet's core and use it as a colossal spacecraft. Fortunately, William Hartnell was on hand to save the day, and when the story reached the big screen in the summer of 1966 as *Daleks – Invasion Earth 2150 A.D.*, the role of the Doctor was taken by Hammer Horror veteran Peter Cushing.

Although comedy actors Ronnie Barker (*The Two Ronnies, Porridge* and *Open All Hours*) and *Dad's Army* favourite John le Mesurier were both born in Bedford (Barker at No. 70 Garfield Street in 1929 and le Mesurier at No. 26 Chaucer Road in 1912), it was another comedy favourite who made a big impact in the town on several occasions during the 1970s. This was the hapless Frank Spencer, played to perfection by Michael Crawford in the popular sitcom *Some Mothers Do 'Ave 'Em*, which was filmed at several locations across Bedford and the surrounding area. These included Bromham Bridge, Chestnut Avenue and Old Ford End Road in Queens Park, Maitland Street, Battison Street, Cranfield Airport and the Stewartby brickworks, where Frank is chased by a falling chimney. One of the series' finest moments, when the Spencers' old terraced house collapses as the couple leave town for a new home, was filmed in the old Argyll Street in the Black Tom area where a large Victorian terrace being cleared as part of redevelopment was demolished to great effect by the film crew.

Created by television scriptwriter Terry Nation (1930–97), the famous Daleks invaded Bedford on both the big and small screens in the mid-1960s. (Julian Vince)

In recent years, the Cardington hangars have played a unique role as a film-making venue where they have assisted in bringing many popular and influential films to the silver screen. For Christopher Nolan's 2005 fantasy saga *Batman Begins*, Shed 1 was transformed into a vast 900-foot-long sound stage to create the 'Narrows', a slum district of Gotham City. Nolan returned to Cardington in 2008 for *The Dark Knight* and again sections of the third instalment of the trilogy, *The Dark Knight Rises* (2012) were also filmed there. All three films featured Christian Bale as the caped crusader.

Way back in 1977, George Lucas used Cardington for the Rebel Alliance's secret base on the fourth moon of the planet Yavin in his groundbreaking sci-fi epic *Star Wars*. While Yavin IV's jungle exterior was filmed on location in Guatemala, Shed 1 was used for interior scenes, with the entrance to the base being created by photographing through a highly detailed painting on a glass sheet to create the effect of a ruined temple building. Nearly forty years later, director Gareth Edwards returned to Cardington, this time to Shed 2, to recreate the Yavin base again for the highly successful *Star Wars* spin-off *Rogue One* (2016).

As well as epic science fiction, the fantasy world of magic and wizardry has been well represented at Cardington in recent years. Scenes for director David Yates' Harry Potter epic *Harry Potter and the Deathly Hallows* from 2011, and the later spin-off *Fantastic Beasts and Where to Find Them* (2016), based on author J. K. Rowling's bestselling fantasy series, were also filmed here.

# 8. Walking Secret Bedford

Like many towns, the history of Bedford, despite being all around, can be difficult to appreciate in busy modern times. Above modern aluminium and glass shopfronts old buildings reveal their former lives. Seemingly innocuous houses have hidden histories that can be easily lost to the past. With this in mind I close this book with a suggested walk around the town centre, which as well as picking up some of the facts and figures already encountered, gives additional historic events and locations. It covers the town centre and the Castle Ward and starting in St Paul's Square is roughly around 1.25 miles. Walking time is around 1.5 hours but if it's a nice day why not spend some time along the Embankment before heading back.

DID YOU KNOW ... ?

Tavistock Street and The Broadway were originally known as Offal Lane. Here in Tudor times the innards and entrails of slaughtered cattle were taken and dumped, hence the original name. For a period in the eighteenth century the name was amended to the slightly better Offa Street as a nod to the King of Mercia we briefly encountered in the opening chapter.

Lime Street gets its name from the town's association with brick making. There was a seventeenth-century lime kiln in St Loyes Street near the western end of what was at one time known as Lime Kiln Lane. In the past it has also been called Queen's Head Lane and Duck's Lane. Foster Hill Road is named after the nineteenth-century Bedford farmer John Foster of Brickhill. He was the author of *Observations on the Agriculture of North Bedfordshire*, a pamphlet on farming techniques published in 1801. De Parys Avenue gets its name from Robert de Parys who founded the St John's Hospital, a home for the sick and aged poor in Bedford around 1180. Newnham Street and Newnham Avenue are named after Newnham Priory, an Augustinian house founded in the twelfth century during the reign of Henry II by Simon de Beauchamp.

We start our walking tour outside the **Corn Exchange**. Opened on 15 April 1874 to replace a previous building now known as the Floral Hall, it has been in continuous use since that time. The first music concerts were given by the Bedford Amateur Musical Society on the day after the official opening. Behind you is the fourteenth-century **Church of St Paul**, a Grade I-listed building. There have been alterations through the centuries

and the great steeple was rebuilt in 1868. It was from the Trinity Chapel here that the BBC broadcast the Daily Service during the Second World War. On Sunday 7 September 1941, a live National Day of Prayer broadcast took place with both Cosmo Lang, the Archbishop of Canterbury, and William Temple, the Archbishop of York, leading the service. By the time of VE Day (or Victory in Europe) took place, Geoffrey Fisher was Archbishop of Canterbury and he made the VE Day Address live from St Paul's, Bedford, on 8 May 1945.

Walk anticlockwise around the church and on the west side of St Paul's Square is the old **Town Hall** (and originally Bedford Grammar School), another listed building which is much older than it appears to be. Originally a Tudor-era structure, the Town Hall was refaced in 1767 to give it the appearance we see today. It was at this time that the statue (the very first such figure erected in the town) was installed in the niche on the main elevation. This is the Bedford merchant Sir William Harpur (1496–1574) who is buried opposite in St Paul's Church. Harpur was a successful businessman and established the Harpur Trust charity. The statue was sculpted by the London mason Benjamin Palmer (c. 1712–78), whose work includes similar busts in Westminster Abbey. For his subject in Bedford, Palmer gave Harpur the Georgian clothes of the day, although in fact he should really be dressed as an Elizabethan gentleman.

The Elizabethan merchant Sir William Harpur (1496–1574) as depicted in a late eighteenth-century engraving.

Carry on round the south side of the square past the **Shire Hall**. This was built between 1879 and 1881 as an improved Magistrates' Court for the Bedford Quarter Sessions and is still in use today. On the east side of St Paul's Square is the familiar statue of the prison reformer **John Howard**, which was unveiled on 28 March 1894. This was commissioned by Bedford Borough Council to commemorate the centenary of Howard's death and was sculpted in bronze by Sir Alfred Gilbert (1854–1934) who also created the famous statue of Eros in London's Piccadilly Circus.

DID YOU KNOW ... ?
Alfred Waterhouse (1830–1905), who designed the Shire Hall in Bedford, was one of the most noted architects of the Victorian period. His work includes many important and iconic buildings across the country including Darlington Market, Strangeways Prison in Manchester, Balliol College in Oxford, the National Liberal Club in Whitehall and the Natural History Museum in South Kensington.

Philanthropist John Howard (1726–90) by the portrait painter Mather Brown (1761–1831). Howard is closely associated with Bedford and its history.

The noted architect Alfred Waterhouse (1830–1905), who designed Bedford's Shire Hall in 1879.

From the Howard statue cross over to the east side of the High Street and head south. On the corner of Castle Lane is **Nos 19–21 High Street**, now a restaurant but originally built as a chemist's shop and home of Charles Frederick Palgrave, Mayor of Bedford in 1849 and 1850. The designer was his nephew, the London architect Robert Palgrave (1831–82) who also designed the facade of the Wesleyan chapel at Kempston in 1859. As you walk down the High Street you will pass the arched entrance of the **Phoenix Chambers**, which can be seen in the 1953 film drama *Personal Affair*.

Carry on down the High Street until you reach **Bedford Bridge** over the River Great Ouse. There has been a crossing here since Saxon times and several different structures have existed, the first most likely a wooden bridge that was built over a ford between the two banks. Using masonry from Bedford Castle, a narrow stone bridge just over 4 metres wide with gatehouses at either end was constructed in the early years of the thirteenth century. Repairs were needed in the closing decades of the 1600s following flood damage and the bridge carried traffic over the Great Ouse for over a century more before the bridge that we see today was built and opened on 1 November 1813. Widening work that doubled the lanes both ways took place shortly before the outbreak of the Second World War.

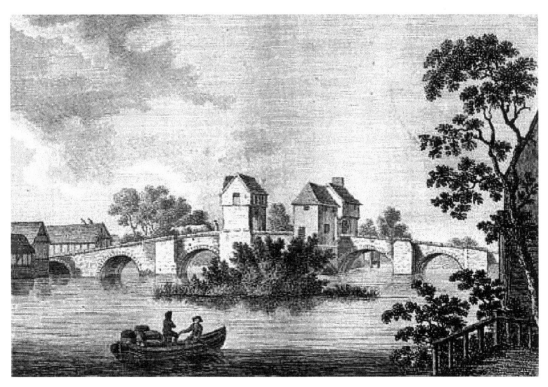

The old bridge across the Great Ouse as depicted in Francis Grose's *Antiquities of England* (1783).

View of the High Street from a pre-widened Bedford Bridge in the 1930s. (Author's collection)

At this point if you want to extend the walk slightly by half a mile carry on over the bridge and make your way south down St John's Street. On the corner of the big roundabout junction with Kingsway you will find the plaque dedicated to the memory of **William Buckingham VC** and the stone marker showing the level of the **Great Flood of 1823**. Make your way back and over the bridge and then carry on heading east along the Embankment where the first feature to be encountered is the **Boer War Memorial**. Commemorating the memory of the 237 Bedfordshire men who fought and died in the Anglo-Boer War in South Africa between 1899 and 1902, it was created by the French sculptor Leon Joseph Chavalliaud (1859–1919) and unveiled on 2 June 1904 by Lady Katrine Cowper, the wife of the then Lord Lieutenant of Bedfordshire, Francis Thomas de Grey Cowper.

Beyond the war memorial is the **Swan Hotel**, a former coaching inn with a long history. The building you see today was built in the last years of the eighteenth century by Francis Russell, the 5th Duke of Bedford. This replaced an earlier inn that stood in the area closer to the High Street. The seventeenth-century staircase inside the Swan is thought to have been salvaged intact from Houghton House on the outskirts of Ampthill.

Carry on along the Embankment where you will see the River Terrace Bar. Now part of the Swan Hotel, this was originally the site of the **Town and Country Club**, built in 1885 to a design by the architect Henry Cheers (1853–1916), whose work also includes Teddington Library and the town halls at Oswestry and West Hartlepool. The club catered for retired Indian Army officers and later for a period of just over ten years beginning in 1957 served as the Bedford County Library before being demolished in 1971.

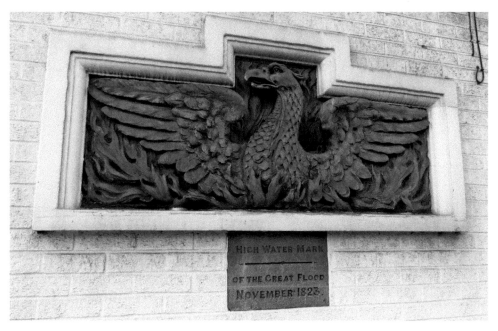

Marker showing the water level of the Great Flood of 1823 on the side of the former Phoenix public house. (Paul Adams)

BLAKE & EDGAR, PHOTOGRAPHERS, BEDFORD.                                    *Copyright.*

## UNVEILING SOLDIERS' MEMORIAL, BEDFORD, JUNE 2nd, 1904.

The grand unveiling of the Bedford Boer War Memorial by Lady Katrine Cowper. (Author's collection)

The Swan Hotel, built near the site of an earlier coaching inn towards the end of the 1700s. (Paul Adams)

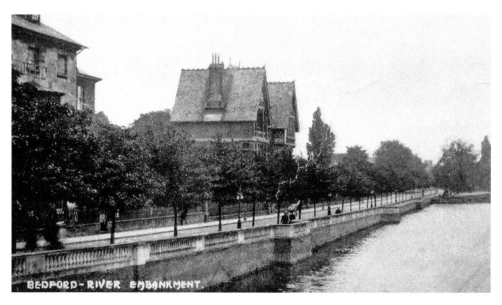

The former Town & Country Club on The Embankment from an early twentieth-century postcard. (Author's collection)

The open area around the Swan statue and access road into the Swan Hotel car park is the site of another two lost Bedford buildings. On the left of the access road was the former **Plaza Cinema**, originally operated by the Chetham family in 1909 as a roller-skating rink and later used for tea dances before being refurbished and opened on 4 March 1929 as a picture palace. The Plaza survived into the 1970s, becoming the Century cinema and then the Nite Spot club and disco before being demolished in the early 1980s. Adjoining the Plaza was the old **Bedford Museum**, which opened in 1962 on the site of a former garage showroom.

At this point take the path to the right of the car park access road and head up the sloping path to what remains of **Bedford Castle**, one of the most prominent locations in the town and a site steeped in history. Only the base of the motte remains of what was once a substantial structure built in the twelfth century by Henry I. Among the notable happenings down through the centuries is the siege of 1224 when against the orders of Henry III, the Anglo-Norman soldier Sir Falkes de Breauté imprisoned the English High Sheriff, Henry of Braybrooke. An assault on the castle began on 20 June 1224 and lasted until 14 August when the defences were finally stormed and de Breauté's men were killed. During the English Civil War, Bedford Castle became a Royalist stronghold and the later expansion of the town has resulted in the castle grounds being swallowed up by buildings and roads.

Leaving Bedford Castle, return to the Embankment and walk east until you reach the junction with Albany Road. On the corner at **No. 1 Albany Road** is the large detached Victorian house where students of the Second World War 'Bedford Spy School' were given lessons in Arabic as part of their training with the code-breaking facility at Bletchley Park. Walk up Albany Road until you reach **No. 12 Albany Road**. This is the house where Mabel Barltrop founded the Panacea Society shortly after the First World War. The house has been preserved by the Panacea Society and the interior is exactly as it was during her lifetime.

*Above*: No. 1 Albany Road, used as a language school by the SOE during the Second World War. (Paul Adams)

*Left*: No. 12 Albany Road, home to Mabel Barltrop, the self-styled prophet of the Panacea Society. (Paul Adams)

DID YOU KNOW ... ?

The Panaceans considered the large ash tree visible from Albany Road in the grounds of the present-day Panacea Museum to be Yggdrasil, the World Ash Tree of Norse mythology which has been featured in many poems and novels. The composer Richard Wagner (1813–83) incorporated Yggdrasil into his monumental Ring Cyle of operas and it even appears in modern heavy metal music by bands such as the Swedish melodic death metal band Amon Amarth.

An early interpretation of Yggdrasil, the World Ash Tree thought by the Panaceans to be growing in the centre of Bedford.

Carry on until you reach the junction with Castle Road. On the corner is **No. 18 Albany Road**, the house prepared by the followers of Mabel Barltrop for the return of Jesus Christ to Earth. From 'The Ark' turn left and walk westwards down Castle Road. At this point you can turn left into Newnham Road and break the walk with a visit to the **Panacea Museum**, which occupies the house reserved for the twenty-four bishops required to be present at the opening of 'Joanna Southcott's box'. The large villa called 'The Haven' on the corner of Newnham Road and Castle Road is also a Panacea house and has a remarkably preserved interior that has remained unchanged from Victorian times.

'The Ark', prepared for the return of Jesus Christ by the followers of 'Octavia'. (Paul Adams)

Continue the walk by heading across to the John Bunyan Museum and on to stop at the junction with Mill Street. The large red-brick building with the portico entrance at **No. 38 Mill Street** is a famous haunted house where unusual happenings have been reported over many years. Phenomena experienced here include the mysterious opening and closing of doors, strange knocking sounds and the sound of unseen people moving about the building. On your right is the **Polish Roman Catholic Church of the Sacred Heart of Jesus and St Cuthbert**. Built in the 1840s on the site of a previous religious building, the church was extended in 1865 by the architect Francis Penrose (1817–1903) who was at one time Surveyor of the Fabric of St Paul's Cathedral, a post originally held by Sir Christopher Wren.

Keeping the Polish RC Church on your right, head east along the remainder of Mill Street and then turn left into St Cuthbert's Street. Further along on the right-hand side is **The Ship** public house where the 'Tennis Lawn Murder' took place in 1883. Further up on the same side is a white rendered Victorian terraced house (No. 17) built on the site of the cottage where **John Bunyan** (1628–88) lived from the middle of the 1650s. Walk the length of St Cuthbert's Street and turn left into St Peter's Street. To the left of the double gates with the eagle design on the opposite side of the road is **No. 30 St Peter's Street** where

No. 38 Mill Street, a haunted house where ghostly phenomena has been experienced over many years. (Paul Adams)

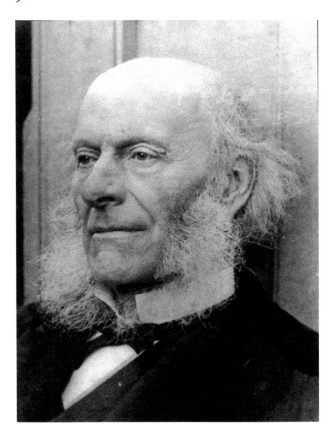

Francis Penrose (1817–1903), ecclesiastical architect whose work includes alterations to the Polish Roman Catholic Church in Castle Road.

the Victorian medium William Stainton Moses died at the home of his mother in 1892. Further along the road on the same side is the **Quarry Theatre** performing arts venue created from the former Moravian church of St Luke's. The first Moravian settlement in England was established in Bedford in 1745 by exiles fleeing religious persecution in the Czech Republic.

Continue heading west along St Peter's Street until you reach the busy junction with The Broadway and the High Street. The modern Lidl supermarket is built on the site of the former **Granada Cinema** where famous pop and rock acts including The Beatles and Jimi Hendrix performed live in the 1960s. At the crossroads is the famous statue of **John Bunyan**, created by the noted Victorian sculptor Sir Joseph Edgar Boehm (1834–90). Boehm sculpted the statue of the Duke of Wellington at Hyde Park Corner in London and also the face of Queen Victoria on the 1877 Jubilee coin. For his statue of Bunyan, a military cannon from the Opium Wars with China was melted down to provide the bronze. The statue, financed by Francis Hastings Russell, the 9th Duke of Bedford, was unveiled before a crowd of over 10,000 people on 10 June 1874 by Lady Augusta Stanley (1822–76), daughter of the 7th Earl of Elgin and lady-in-waiting to Queen Victoria. Opposite the Bunyan statue on the corner of The Broadway and Dame Alice Street is **Ardur House**. A former gas showroom, the first floor was the first premises used by the 'Bedford Spy School' during the Second World War.

*Above*: View of St Peter's Street and the Bunyan statue in the 1930s. (Author's collection)

*Right*: The Victorian sculptor Sir Joseph Edgar Boehm (1834–90) who created the famous statue of preacher John Bunyan.

Continue the walk westwards along Dame Alice Street, named after Dame Alice Harpur (d. 1569), the Elizabethan wife of William Harpur whose statue we have already encountered in St Paul's Square. On the north side of the street are the beautiful **Harpur Trust Almshouses**, which were built in a Neo-Tudor red-brick style at the beginning of the nineteenth century. A similar row of almshouses on the same side beginning after the junction with Harpur Street was demolished in 1969.

DID YOU KNOW ... ?

Guglielmo Marconi (1874–1937), the Italian inventor and pioneer of radio transmission, lived in Bedford in the late 1870s. Born in Bologna, Marconi came to England with his mother when he was two years old and together with his brother Alfonso received his first formal education at Bedford School before returning to Italy in 1880. In 1909, he shared the Nobel Prize in Physics with Karl Braun (1850–1918) for his contribution to wireless telegraphy. The house where he lived is No. 41 Harpur Street, just north of the junction with Dame Alice Street.

Guglielmo Marconi (1874–1937), the radio pioneer who lived in Harpur Street, Bedford, during the 1870s.

Walk along Dame Alice Street until you reach **Bedford Prison**. The modern section was built in the early 1990s while the older building with its great curved walls dates from 1801. Notices of executions were posted on the large wooden gates fronting the road. Jack Day from Dunstable and the 'A6 Murderer' James Hanratty, originally from Bromley in Kent, were the last two men to hang here in the early 1960s.

We are coming now to the final part of our walk. From Bedford Prison turn the corner into St Loyes Street and then go immediately right into the pedestrianised precinct which follows the course of the old Allhallows Lane. The 1970s development on your immediate right occupies the site of the former **St Paul's Mission Hall** used as a studio by the BBC Theatre Orchestra during the Second World War. This entire area has been redeveloped in recent years and most of the pre-war buildings have now gone.

Carry on down Allhallows Lane and then turn left and walk along Silver Street. Also known as Little Silver Street in the past, the name most likely comes from Saxon times where the term was reasonably common for main thoroughfares rather than the presence of silversmiths in this part of the town. The noted modern sculptor Ian Homer Walters (1930–2006) created the bust of the former Bishop of Stepney and anti-apartheid campaigner **Trevor Huddleston** (1913–98), the original of which is in South Africa House in London. The bust in Silver Street is a copy, originally unveiled in October 1999 and subsequently rededicated by Nelson Mandela during a visit to Bedford on 7 April 2000.

The gates of Bedford Prison, where execution notices were displayed during the years of capital punishment. (Paul Adams)

Bishop Trevor Huddleston (1913–98), whose anti-apartheid work is celebrated in Silver Street, blessing the congregation at St Nichols' Church, Dar es Salaam, on 30 November 1960. (The National Archives UK)

You can't miss the huge *Reflections of Bedford* sculpture at the junction of Silver Street and the High Street created by the English sculptor Rick Kirby (b. 1952) as a symbol of modern ethnic diversity in the town. What is not readily apparent is that the 1940s development on the corner of Silver Street and the High Street occupies the site of the old **Bedford Gaol** which was visited by John Howard and where John Bunyan was kept prisoner. Silver Street was also known as Gaol Lane in days gone by.

Walk south down the High Street and you will soon come to St Paul's Square, where we began and where our tour and look at the world of secret Bedford also comes to an end. I hope you have found it of interest.

# Bibliography and Further Reading

Bailey, Brian, *Hangmen of England* (London: W. H. Allen, 1989)

Benson, Michael, *Bedford's Musical Society* (Woodbridge: The Boydell Press, 2015)

Broughall, Tony and Paul Adams, *Two Haunted Counties* (Luton: Limbury Press, 2010)

Bunker, Stephen, *The Spy Capital of Britain: Bedfordshire's Secret War 1939–45* (Bedford: Bedford Chronicles, 2007)

Fuller, John G., *The Airmen Who Would Not Die* (London: Souvenir Press, 1979)

Godber, Joyce, *The Story of Bedford: An Outline History* (Luton: White Crescent Press, 1978)

Halpenny, Bruce Barrymore, *Ghost Stations III* (Chester-le-Street: Casdec Ltd, 1990)

Kenyon, Nicholas, *The BBC Symphony Orchestra 1930–1980* (London: BBC, 1981)

King, William, *Haunted Bedford* (Stroud: The History Press, 2012)

Kinsey, Wayne and Gordon Thomson, *Hammer Films on Location* (Barnby: Peveril Publishing, 2012)

Marks, Leo, *Between Silk and Cyanide* (London: Harper Collins, 1998)

McLaughlin, Stewart, *Harry Allen: Britain's Last Hangman* (London: True Crime Library, 2008)

Normanton, Helena (Ed.), *Trial of Alfred Arthur Rouse* (London: William Hodge & Co. Ltd, 1931)

O'Connor, Bernard, *'Nobby Clarke: Churchill's 'Backroom Boy'* (Bedford: Lulu, 2010)

O'Connor, Bernard, *The Bedford Spy School* (Bedford: Lulu, 2010)

Price, Harry, *Confessions of a Ghost-Hunter* (London: Putnam, 1936)

Risby, Stephen, *Prisoners of War in Bedfordshire* (Stroud: Amberley Publishing, 2011)

Seaton, Derek, *A Tiger and a Fusilier: Leicester's VC Heroes* (Botcheston: D. Seaton, 2001)

Shaw, Jane, *Octavia, Daughter of God* (London: Yale University Press, 2011)

Simpson, Keith, *Forty Years of Murder* (London: Harrap, 1978)

Turner, Des, *SOE's Secret Weapon's Centre: Station 12* (Stroud: The History Press, 2011)

# Acknowledgements

A book such as this is very much a collaborative project and I would like to thank the following people who have helped in providing information and illustrations: Colin Crane, Eddie Brazil, David Williams, Lucie Skeaping, Dennis M. Spragg, Mary Tranquada, Jeni Melia, Sandra Johnson and the 'You Grew Up in Bedford if You Remember...' Facebook group, Valerie Harper-Skelton, Tony Milioti, Julian Vince, Bernard Hewitt, Hannah Robertson, Philip Briggs, Alexandros Kozak, Bernard O'Connor, Jayne Plackett and the True Crime Library, and Stewart McLaughlin and the Wandsworth Prison Museum. The Bedfordshire Archives and Records Service has been of particular help in sourcing information, as have publications made available by Bedford Borough Council.

Every effort has been made to trace and contact copyright holders of photographs and illustrations used in this book. The publishers will be pleased to correct any mistakes or omissions in future editions.

## By the Same Author
*The Borley Rectory Companion*
*Shadows in the Nave*
*Extreme Hauntings*
*Haunted Luton & Dunstable*
*Haunted St Albans*
*Haunted Stevenage*
*The Little Book of Ghosts*
*Ghosts & Gallows*
*Written in Blood*
*The Enigma of Rosalie*
*Secret Luton*